IMAGES
of America

HERSHEYPARK

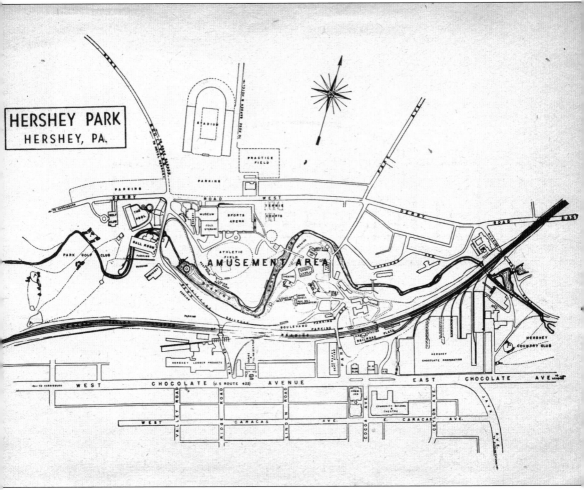

HERSHEY PARK, C. 1940. By 1940 Hershey Park was known as Pennsylvania's summer playground. During the 1930s several new rides and facilities transformed Hershey into a major tourist destination. People enjoyed visiting Hershey because of the variety of activities available. In addition to the park rides, visitors could tour the chocolate factory, swim in the swimming pool, play a round of golf, listen to a band concert, and at night, dance to the sounds of a national big band.

On the cover: **CUSTER CAR RIDE, 1936.** Developed by Ohio inventor Levitt Luzern Custer, the Custer Car Ride was added to Hershey Park in 1936. The cars were powered by electric motors. This ride was the first of the park's turnpike rides. During the 1930s Hershey Park added several rides and attractions and marketed the park as Pennsylvania's summer playground. (Courtesy of Hershey Community Archives.)

IMAGES
of America

HERSHEYPARK

Pamela Cassidy Whitenack

ARCADIA
PUBLISHING

Published by Arcadia Publishing
Charleston SC, Chicago IL, Portsmouth NH, San Francisco CA

Printed in the United States of America

Library of Congress Catalog Card Number: 2006926777

For all general information contact Arcadia Publishing at:
Telephone 843-853-2070
Fax 843-853-0044
E-mail sales@arcadiapublishing.com
For customer service and orders:
Toll-Free 1-888-313-2665

Visit us on the Internet at www.arcadiapublishing.com

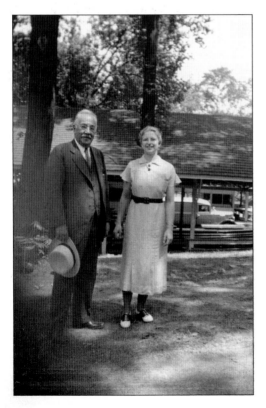

MILTON HERSHEY, AUGUST 1938. Hershey Park was an important part of Milton Hershey's plans for his new model town. During his lifetime, Milton Hershey took a personal interest in the park's development and was involved in the decisions concerning adding new rides, bringing in entertainment, and expanding the park. He frequently visited the park. He enjoyed listening to band concerts at the bandstand, attending baseball games at the athletic field, and simply strolling through the park to see for himself how other visitors enjoyed and appreciated the park's amenities.

CONTENTS

ACKNOWLEDGMENTS

Most of this book's research was conducted at the Hershey Community Archives. The archives serve as corporate archives for Hershey Entertainment and Resorts Company. It holds a wealth of materials relating to the history of the park. In addition, the archives's oral history collection contains a wealth of stories about Hershey Park that helped to shape this book's narrative. Charles Jacques's book, *Hersheypark, The Sweetest of Success*, was an invaluable resource.

This book would not have been possible without the generous support of many individuals. Gary Popp, Hersheypark complex director of retail, first conceived of the book and invited my participation. Many people shared their love and knowledge of the park with me. Many thanks to Gary Chubb, J. Bruce McKinney, Paul Serff, Harold Sitler, John Tshudy, Matt Loser, and Kathy Burrows. Special thanks goes to Neil Fasnacht, a friend and Hershey collector, who freely shared his knowledge and collection with me.

Judy Grow and Diane Summers, of the Hershey Community Archives staff, patiently pulled research materials and photographs for the book. While the book was in draft form a number of people read the manuscript and offered helpful comments and corrections. Many thanks to Amy Bischof, Mindy Bianca, Kathy Burrows, Andrew Cassidy-Amstutz, Jennifer Goss, Andrew Keefer, Jennifer Kramer, Jill Manley, Gary Popp, and Don Rhoads. Responsibility for the final text, including any factual errors or omissions, rests with the author.

Special thanks to the men in my life, husband David Whitenack and son Christian Cassidy-Amstutz, for all their patience, love, and understanding during the many hours and weekends spent working on this book.

Throughout the book credit to the owner of the photographs has been given. Images without a credit are from the Hershey Community Archives.

INTRODUCTION

A model industrial town was established in 1903 as part of Milton Hershey's plan to build a new factory for his rapidly growing business, the Hershey Chocolate Company. The chocolate business had been established in 1894 as a subsidiary of his enormously successful Lancaster Caramel Company that marketed a broad range of caramel products across the United States and throughout Europe.

Hershey Chocolate Company's first products were not the famous milk chocolate but rather a wide variety of dark chocolate novelties. Inspired by the success of the Lancaster Caramel Company's fresh milk caramels, Milton Hershey soon began experimenting with fresh milk with the goal of developing a formula for milk chocolate. Hershey's Milk Chocolate was first introduced in 1900. The immediate success of Hershey's Milk Chocolate led to the need to build a new factory. After examining possible sites up and down the eastern seaboard, Milton Hershey decided to build the new factory near his birthplace in Derry Township, Pennsylvania.

While business associates questioned the wisdom of building a large factory in rural central Pennsylvania, Milton Hershey knew he was going to build more than a factory. Along with the chocolate business, he planned to build a model industrial town. Plans for the new town included comfortable, modern housing for his workers, an up-to-date public education system for the children, retail services, and recreational opportunities. Hershey Park would be an important part of Milton Hershey's plans for his model industrial town.

Workers broke ground for the factory on March 2, 1903. The factory was completed in 1905, and production of Hershey's Milk Chocolate bars began that summer. While the factory was still under construction, Hershey also began laying out an extensive trolley transit system. The trolley system connected the new town with the surrounding communities, making it possible for workers to live elsewhere and commute to work for just a nickel. The trolleys also made it easy for town residents to shop in and visit nearby towns. Just as important, trolleys transported milk to the chocolate factory.

It was important to Milton Hershey that the town be attractive as well as functional. He wanted to create an environment that would nurture and support his workers. He hired Oglesby Paul, the landscape architect responsible for the design of Philadelphia's Fairmount Park, to create a landscape plan for the town. Trees, open green areas, and public gardens were important elements of the town's design. The many farms that Milton Hershey purchased to ensure a good supply of milk for his factory created a green buffer zone for the new town. Harry N. Herr, a civil engineer from Lancaster, Pennsylvania, was responsible for planning the infrastructure of the entire community.

Residential areas were laid out at the same time that the factory was being designed. Milton Hershey wanted workers to have a personal stake in the new town. In addition to renting, workers were encouraged to buy newly constructed houses or purchase a lot and put up their

own homes. Deed restrictions ensured the quality of new home construction by dictating the inclusion of front and back yards and prohibiting most outbuildings including chicken coops, pigpens, and businesses such as tanneries and glue factories. Milton Hershey was insistent that the houses be attractive and not all of the same design. He did not want Hershey to look like a typical company town, marked by grey smokestacks, polluted air, and rows of tenement shacks.

Providing for public education was important to Milton Hershey. In 1904, he offered land and money to Derry Township School District for the construction of the township's first high school. As the town grew, Milton Hershey constructed a number of school buildings and donated them to the school district. His first major gift, the M. S. Hershey Consolidated School, provided quality centralized education for grades 1 through 12, replacing 14 one-room schools in Derry Township. In 1929, Milton Hershey also helped establish a vocational education program, providing a building and underwriting its operating costs each year. In 1938, he funded the Hershey Junior College, which offered two years of free college education to Hershey workers and residents. The junior college operated until 1965 when it merged with the newly established Harrisburg Area Community College.

Community initiatives to establish service organizations were supported by Milton Hershey with gifts of space and financial support. Hershey Volunteer Fire Company was first established in 1905. Still operating today, it continues to protect the community with a high level of volunteer professionalism. Other service organizations were also established in the community, including the YMCA in 1910 and the YWCA in 1911. A variety of literary and social clubs, community bands and orchestras, and local sports teams were also formed. While many of the groups have changed over the years, the Hershey community has maintained a tradition of offering a variety of outlets for entertainment and service.

Town services stretched beyond providing for basic needs. In the early 20th century when many homes still did not have indoor plumbing, electricity or telephone service, all Hershey homes incorporated these services. To provide these services, Milton Hershey established a wide array of utility companies, including Hershey Electric Company, Hershey Sewerage Company, Hershey Telephone Company, and Hershey Water Company. These operations continued to provide service to the town until the 1960s when they were sold to larger, regional businesses.

Milton Hershey provided a wide variety of retail services. Hershey Trust Company, established in 1905, offered checking and savings accounts, mortgages, and commercial and personal loans as well as traditional trust account services. As the town grew and banking needs expanded, Hershey National Bank was established in 1925 to handle the town's retail banking services. In addition, Milton Hershey provided a laundry, a gas station, a blacksmith shop, a printing shop, a café, a barbershop, a post office, and a department store. As the community grew, these businesses expanded both in number of services and size.

Even while Milton Hershey invested heavily in the town's development, the chocolate business generated more profit than Milton Hershey and his wife, Catherine, were able to spend. The Hersheys' solution was to establish the Hershey Industrial School (today named Milton Hershey School) for orphan boys in 1909. The Hersheys sought to put their wealth to good use by helping children in need. Today the school is Milton Hershey's most visible legacy, providing a secure home and a quality education to both boys and girls who are in financial and social need.

A cornerstone of Milton Hershey's plans for his model town was his desire to incorporate space and opportunities for recreation. Land was set aside for a town park from the very beginning. Initially the park developed as a community picnic grounds with a bandstand and children's playgrounds. The growth of the town soon had a significant impact on the park's development. As the factory expanded and the town grew, many articles were published about Milton Hershey's model industrial town. The idea of building a factory town to benefit the workers caught the public's imagination. The town soon became a tourist attraction. Increasing numbers of visitors coming to see the much publicized model town made Milton Hershey realize that the town could be marketed. Hershey Park quickly developed along the lines of a trolley park as rides and other amusements were added.

One

HERSHEY PARK
FROM PICNIC GROUNDS TO AMUSEMENT PARK

As electric trolley lines developed in American cities during the late 19th century, parks developed at the end of the lines as trolley companies sought ways to increase ridership during weekends. These trolley parks started out simply with picnic grounds, dance halls, games, and a few amusement rides. The first parks were quickly successful and new ones opened across the United States.

Coney Island was the center for New York City amusement. Its development as a popular leisure destination began in the mid-19th century as people came to Coney Island for its cool ocean breezes. An 1875 railroad link spurred its development and Coney Island soon became known for its amusements, including vaudeville, games, restaurants, and rides such as carrousels. Coney Island's popularity led to the establishment of several amusement parks. These amusement parks featured rides as the main attraction, rather than a natural feature such as the ocean or a lake. Coney Island's success encouraged many entrepreneurs who owned a picnic grove or summer resort to develop their own amusement park.

As he laid out his model industrial town, Milton Hershey earmarked 150 acres of land for the park in 1903. The land was located north of the town and the factory. Original plans for the park were modest. Spring Creek meandered through the location and became a focal point for the beautifully landscaped park. The entrance featured an open lawn with extensive flower beds as well as newly planted trees and shrubs. A large pavilion, built in 1904, provided space for entertainment, dancing, and roller skating, even before the park officially opened. A newly established community band performed in the park throughout the summer season. Milton Hershey provided instruments and uniforms and encouraged his workers to join the band. A bandstand was soon built to provide a proper setting for concerts.

In an era when many rural areas did not yet have electricity, Hershey Park was lit by electricity supplied by the chocolate factory's generators. Electric lights along many pathways and in the dance pavilion made the park an impressive sight at night. Soon after the Hershey Chocolate Factory opened in 1905, baseball teams were organized by factory workers and residents, prompting the construction of a baseball field.

The evolution of Hershey Park from community park to amusement park was encouraged by its proximity to the Philadelphia and Reading Railroad. The local railroad station was relocated from nearby Derry Church to Hershey and the chocolate factory in 1906. The new station was located just across the street from the park's main entrance. As Hershey Park developed, the railroad offered special excursion trains to the park from Harrisburg, Lebanon, Lancaster, and beyond at reduced rates. Hershey Park quickly became the destination of choice for hundreds of businesses, churches, and entire towns who organized group days at the park.

Hershey Park was also served by Hershey's trolley transit system. With a fare of just 5¢, the trolley was a primary means of transportation for local communities to travel to the park in the early years. Like the railroad, the trolley ran special picnic cars on the weekends.

More entertainment was added for the park's second year. In addition to weekly band concerts, vaudeville acts were booked to perform in the park pavilion throughout the summer season. In

1908 the park's first official ride, a small, used carrousel and band organ, was purchased. It was installed in a new pavilion on the far side of the park, near the baseball field.

Each year saw new improvements to the park. In 1909 an amphitheater, two bowling alleys, and a photographic gallery were added. The following year, the park's miniature railroad opened. The miniature railroad ran from the park's main entrance around the outskirts of the park to the baseball grandstands. The 22-inch gauge railway was built by the Lancaster Iron Works from Lancaster, Pennsylvania. At the time it was built, the little one-of-a-kind railway was considered a technological achievement.

The year 1910 marked the formal opening of the Hershey Zoo. The zoo had its origins in 1905 when Milton Hershey accepted a group of prairie dogs and had a pen built to hold them on park grounds. The prairie dogs were soon joined by a black bear. The early zoo grew slowly with a variety of animals donations.

During the second decade of the 20th century, new rides and attractions were added every year. Hershey Park's 1908 swimming pool was improved and enlarged for the 1912 season. The original carrousel was replaced in 1912 with a larger one that was designed by one of the premier carrousel makers, William Dentzel of Philadelphia, Pennsylvania. The bandstand was enlarged again in 1914. In 1915, the Convention Hall, with seating for 6,000, opened, providing Hershey with a large-scale venue to host major conventions and performers.

World War I created a worker shortage and park hours were shortened. Wartime restrictions caused the railroad and trolley service to discontinue special park excursion trains and rates. Even with these limitations, the park continued to present vaudeville and summer stock, as well as movies in the main pavilion. Ballroom dancing, first introduced in 1910, continued to grow in popularity during the war years.

Hershey Park's fortunes mirrored the fortunes of the Hershey Chocolate Company. In 1919, following the war, Milton Hershey gambled on sugar futures and lost. The chocolate company was forced to heavily mortgage itself and the lending bank sent an administrator to oversee the company's finances. Spending at the factory and throughout the town was sharply curtailed. Herculean efforts were made by all employees to increase productivity and in three years the chocolate company's profits had improved so that the debt could be refinanced and the bank's administrator was removed. To celebrate and in honor of the town's 20th anniversary, Milton Hershey ordered a roller coaster for the park.

With the Wild Cat roller coaster, Hershey Park was following and responding to new trends in amusement park development. The 1920s were a decade of optimism and energy. Amusement parks were booming and owners continually looked for ways to thrill their visitors. Hershey Park followed this trend and opened two more thrill rides during the decade, bumper cars and the Mill Chute water flume.

The stock market crash and the Great Depression took a terrible toll on amusement parks across the United States. Hundreds of parks were forced to close as attendance dropped and park owners had no money to invest in maintaining or developing their parks. However, Hershey Park, backed by Milton Hershey and the continued success of the Hershey Chocolate Corporation, added several new rides during the 1930s. It was during this time that the arena and stadium were also added to the park complex, providing unique and large scale venues quite unusual for a "trolley park."

This era was also the heyday of big bands and the Hershey Park Ballroom continued as a popular destination. By the end of the 1930s, Hershey Park was being marketed as "Pennsylvania's Summer Playground."

World War II had a dramatic impact on park operations. Gas rationing curtailed visitation, though trains and trolleys continued to bring visitors to the park. The zoo closed in 1942 and the ballroom also closed for a few years as a result of gas rationing.

The end of World War II brought relief and the hope that life would return to normal on the home front and in Hershey. The end of the war was celebrated at Hershey Park with the addition of a new roller coaster, the Comet. Opening for the 1946 season, it would be the park's last hurrah for few decades.

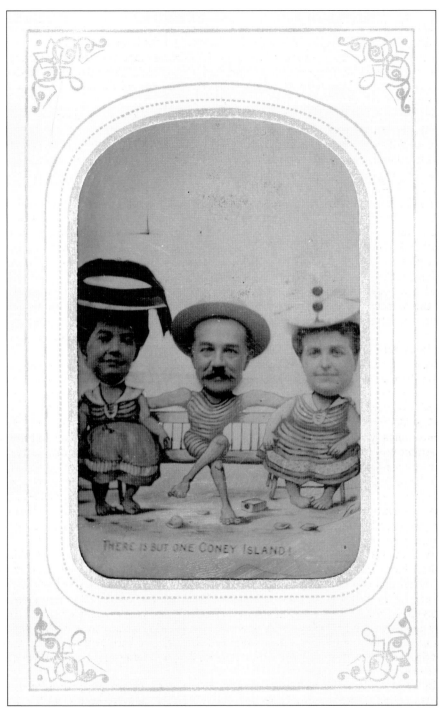

CONEY ISLAND SOUVENIR, C. 1910. Milton Hershey enjoyed visiting amusement parks. He and his wife, Catherine, traveled extensively, both in the United States and abroad. This souvenir photograph was created during a visit to New York City and Coney Island. From left to right are Catherine Hershey, Milton Hershey, and Adeline Jackson. Milton Hershey may have gathered many ideas for developing his own amusement park during his visit.

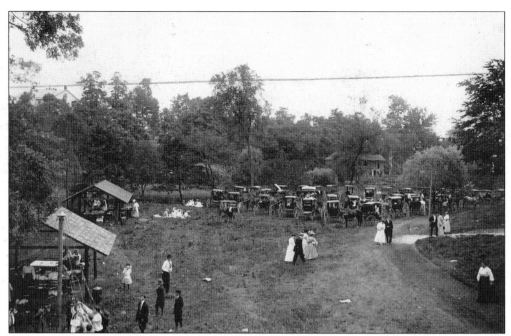

HERSHEY PARK, C. 1906. Even before it officially opened in 1906, the park was a popular destination for local residents. Spring Creek meandered through the park, making it an attractive and shady place to gather for picnics and outings. Modest picnic pavilions and playgrounds were placed throughout the park's grounds.

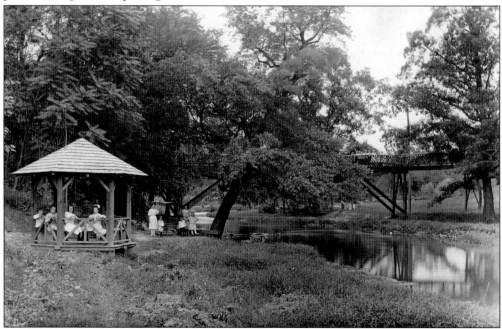

CHILDREN'S PLAYGROUND, 1909. Hershey Park retained its rural character for many years. For its first several years, the park was popular as a picnic grounds and as a place to relax and unwind. Spring Creek wound its way through the park, enhancing the landscape's natural beauty. The first attractions built were small pavilions that dotted the park.

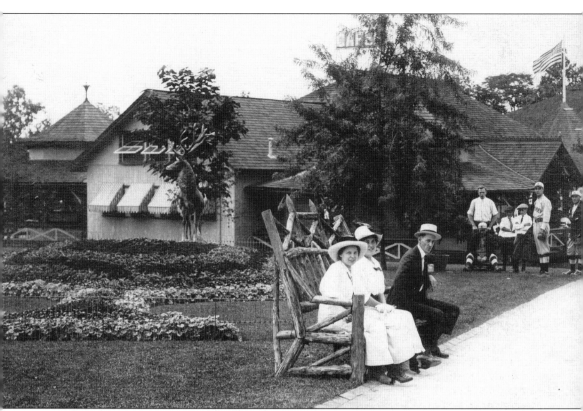

HERSHEY PARK, AROUND 1908–1910. Hershey Park's main entrance was located close to Hershey's railroad station. People arriving by train could simply walk down the hill to enter the park. Rustic benches lined the walks. Some of the earliest structures built for the park included a dance pavilion, a bowling alley, an information bureau, and a café. (Courtesy of Neil Fasnacht.)

ENTRANCE TO HERSHEY PARK, C. 1910. Attractive landscaping was very important to Milton Hershey. He hired Olgesby Paul, a noted landscape architect responsible for the design of Philadelphia's Fairmount Park, to develop landscaping plans for Hershey. The park featured lawns and extensive flower beds. The Elk statue seen in the background was a popular landmark.

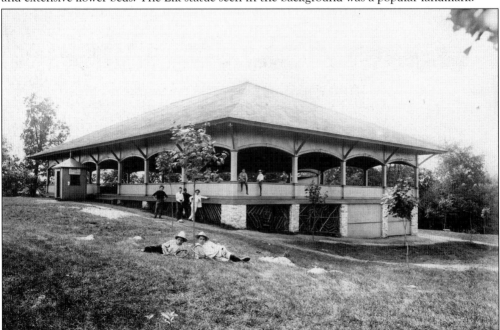

MAIN PAVILION, C. 1906. Before the park had officially opened, a large open-air pavilion was constructed in 1904 for dances and roller-skating. It was soon enlarged and enclosed, and a stage was added to permit its use as a theater. The park band used the pavilion in winter months for practices. The pavilion was located on a hill overlooking Spring Creek, near the future amphitheater.

EASTERN ENTRANCE TO HERSHEY PARK, C. 1917. Hershey was extensively landscaped throughout the town as well as in the park. In addition to numerous flower beds and shrubbery, large planters could be found throughout the town. As automotive travel became more popular, the park had to create new parking areas to handle the growing numbers of cars traveling to Hershey.

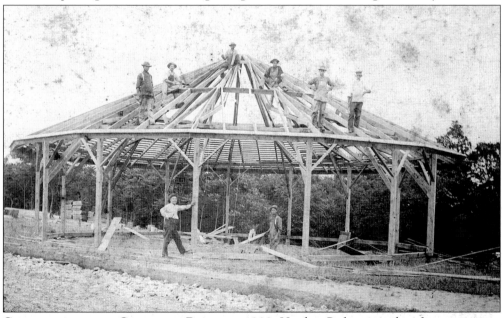

CONSTRUCTING THE CARROUSEL PAVILION, 1908. Hershey Park acquired its first amusement ride in 1908 when it purchased a small used carrousel and band organ from the Herschell Spillman Company of North Tonawanda, New York. It cost $1,500, while a new carrousel would have cost more than $2,000. When the carrousel's band organ played it could be heard three blocks away on Chocolate Avenue. (Courtesy of Neil Fasnacht.)

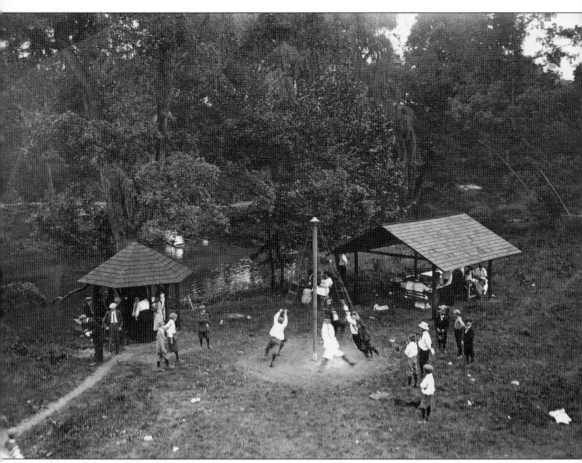

CHILDREN'S PLAYGROUND, C. 1910. From its inception, Hershey Park was designed with families in mind. In addition to picnic pavilions, children's playgrounds dotted the park, offering slides, swings, and teeter-totters. Hershey Park was slow to add the type of amusement rides people now remember best about the park. For the first several years, people visited the park to enjoy band concerts, ball games, and simply stroll through the scenic grounds. In a rural area such as Hershey, the park's public playgrounds were a novel and appreciated attraction.

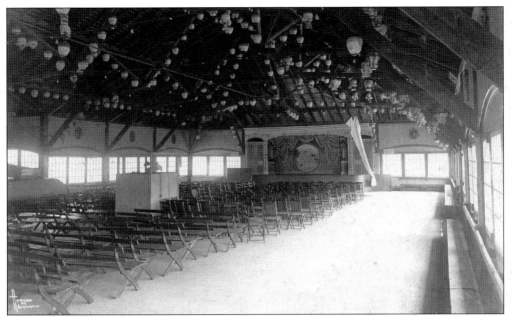

DANCE PAVILION, C. 1910. A stage was added to the park pavilion in 1908. In addition to dances and roller-skating, the pavilion was also used as a theater. The stage curtain featured a scene of workers harvesting cocoa beans. Hundreds of Japanese lanterns created a festive effect. In a time period where electric lights were still uncommon in rural places, the lanterns would have made the pavilion a fanciful place.

HERSHEY PARK CONSERVATORY, C. 1915. Located near the park's main entrance, the conservatory was one of three in the community. The conservatory was used to winter the large number of potted tropical plants and trees that were placed throughout Hershey during the summer months. In the spring it featured beautiful displays of spring flowers and bedding plants that would be moved to the outdoor beds when the weather turned warm.

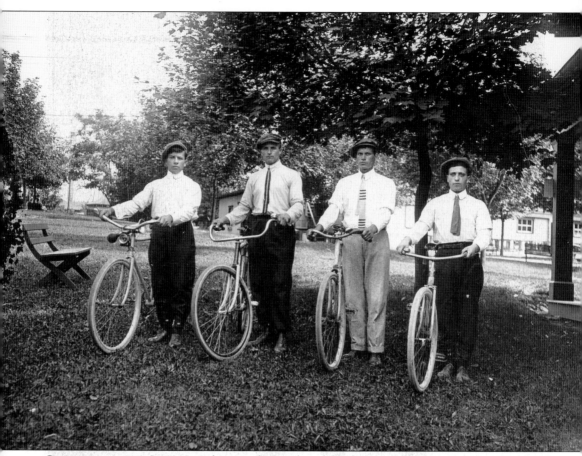

CYCLISTS, C. 1915. In 1909, a photographic studio was added to the park's amenities. The first photographer was Harry Stoner. Visitors could have portraits of themselves created as mementos of their visit to Hershey Park. The studio eventually moved to the Hershey Department Store and operated year round, but a summertime studio continued to operate in the park for many years.

SCENE IN HERSHEY PARK
Home of the Hershey Chocolate Co., Hershey, Pa.

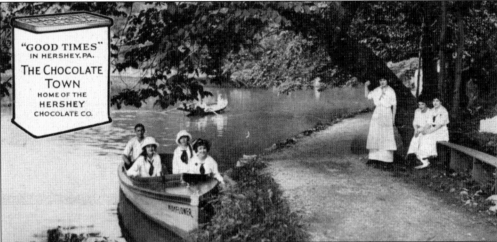

"GOOD TIMES"
IN HERSHEY, PA.
THE CHOCOLATE
TOWN
HOME OF THE
HERSHEY
CHOCOLATE CO.

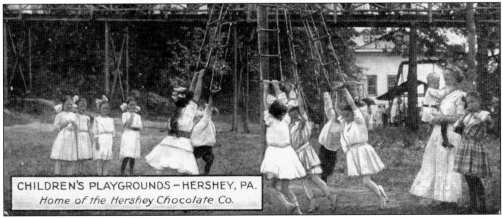

CHILDREN'S PLAYGROUNDS – HERSHEY, PA.
Home of the Hershey Chocolate Co.

CHOCOLATE BAR POSTCARDS, AROUND 1909–1918. Realizing that his model town could be a marketing tool, Milton Hershey had millions of specially sized postcards inserted in standard size milk chocolate bars. The postcards featured scenes of the factory, the community, and Hershey Park. Soon millions of people across the United States knew that there was a Hershey Park. The park also mailed them to businesses and churches soliciting group picnic business.

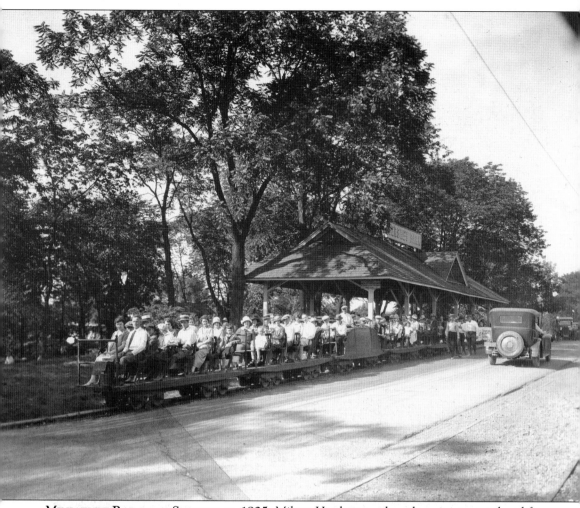

MINIATURE RAILROAD STATION, C. 1925. Milton Hershey purchased a miniature railroad for the 1910 park season. Problems with installation delayed its opening until September 5, 1910. The 22-inch gauge railway was built by the Lancaster Iron Works, Lancaster, Pennsylvania. The ride connected the ends of the park. The train line started at the intersection of Park Avenue and Park Boulevard and traveled around the edge of the park ending by the ball field. The train line had no loop so the line had only one train. The cars could carry up to 30 passengers, and the seats had movable backs so that passengers would always travel facing forward. The fare was 5¢ for a one-way ride. People enjoyed the ride because it was more than an amusement ride, it was a fun way of traveling to a variety of park attractions.

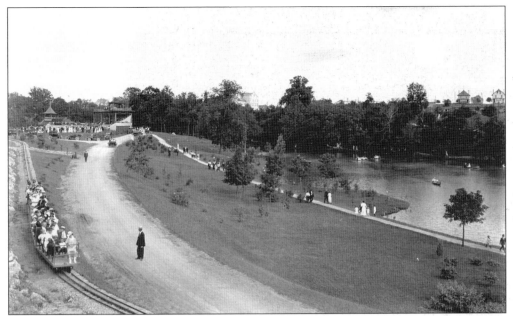

WEST END OF HERSHEY PARK, 1916. Hershey Park covered 150 acres. In the early years the park was enjoyed for its extensive lawns, flower beds, and its footpaths that encouraged leisurely strolls. The athletic field was located in the western end of the park and was a popular destination whenever baseball games were being played. The ball field could be reached by foot or by taking a ride on the miniature railroad.

HERSHEY ZOO, WINTER 1910. The zoo's first shipment of deer was delivered in early January 1910. William "Lebbie" Lebkicher seemed to have been particularly interested in the zoo and was often mentioned in conjunction with acquiring new animals for the zoo. The animals ranged from the mundane to the exotic. In 1910, the zoo acquired two black bears, a pair of zebus, a family of opossums, deer, angora goats, pheasants, three peacocks, and fox squirrels.

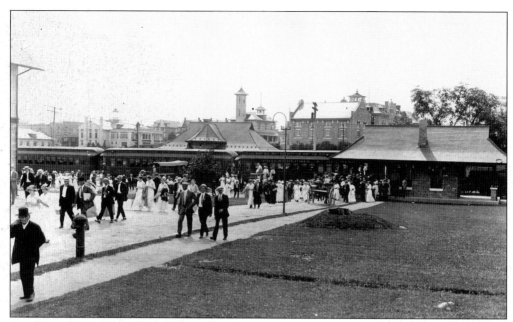

ARRIVING AT HERSHEY RAILROAD STATION, C. 1915. Growing numbers of visitors, coming to visit the new model community, sparked the growth of the park. Hershey offered a wide variety of attractions to see and experience. Many visitors brought picnic baskets to spend the day at Hershey. Specially designed railroad cars carried all of the travelers' picnic baskets and delivered them to the park.

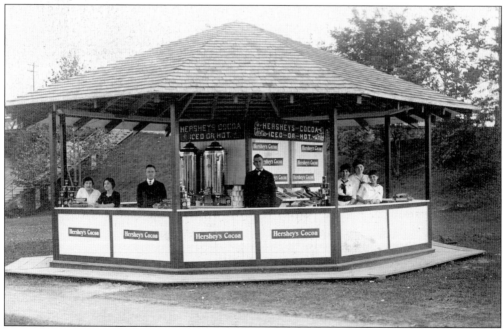

CONCESSION STAND, C. 1910. Hershey constructed a concession stand and placed it next to the railroad station. It catered to visitors arriving and departing by train, offering hot and cold cocoa. Visitors could also purchase tins of Hershey's Cocoa as well as Hershey's Milk Chocolate bars. (Courtesy of Neil Fasnacht.)

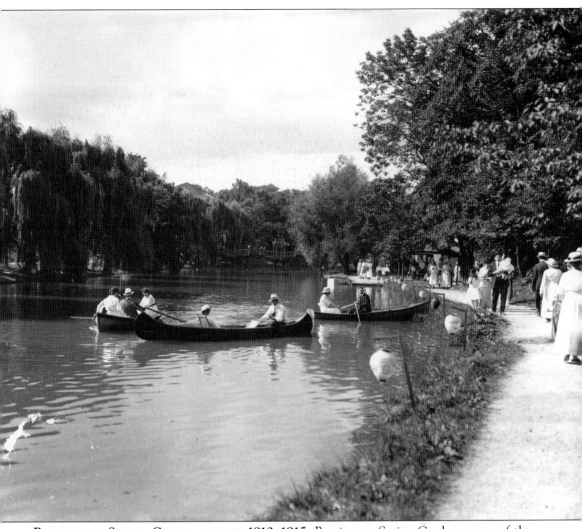

BOATING ON SPRING CREEK, AROUND 1910–1915. Boating on Spring Creek was one of the park's earliest attractions. Spring Creek was dammed to create a large lake for boating and scenic bridges, and overlooks were added to enhance the park's natural beauty. A variety of boats and canoes were available for rent. Boating was a popular activity for couples seeking romance. Creek side paths and pavilions provided many opportunities to enjoy the sight of boats on the water. Note the Japanese lanterns that lined the walk creating a romantic setting for an evening stroll.

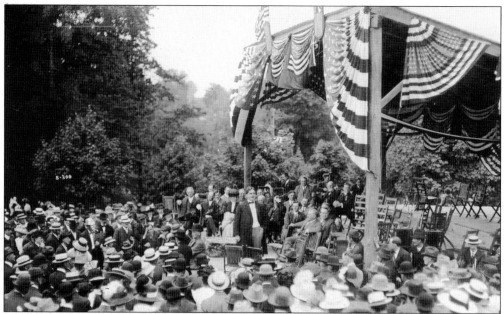

HERSHEY'S 10TH ANNIVERSARY CELEBRATION, 1913. In honor of the community's 10th anniversary, Hershey hosted a weekend-long celebration with a huge parade, airplane demonstrations, concerts, sporting events, and a fireworks display, all held at the park. Omar Hershey (center), a Baltimore attorney, gave a speech on "The Hershey Idea." Milton Hershey is seated on the stage to the right of the speaker.

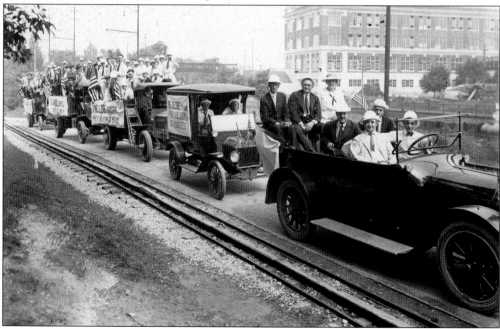

EMPLOYEE DAY AT THE PARK, AROUND 1916–1920. Many businesses made Hershey Park their annual destination for company picnics. Businesses arrived by train, trolley, and in automotive caravans. The park offered large picnic pavilions, catering, and opportunities for baseball games and other sporting events in addition to the park's usual amusements.

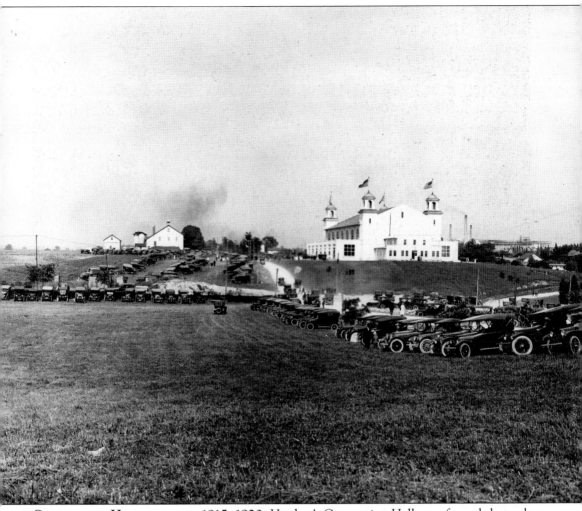

CONVENTION HALL, AROUND 1915–1920. Hershey's Convention Hall transformed the park from an attractive park to a major destination capable of hosting large groups and events. Built to accommodate the needs of the Church of the Brethren's 1915 triennial convention, the Convention Hall could seat 6,000 people. Milton Hershey hoped that it would serve as a Chautauqua hall and bring a wide variety of educational and entertaining programs to the community. While it never formally provided structured classes, it was used both as a hall for conventions and for performances. A wide variety of nationally recognized performers appeared at the Convention Hall.

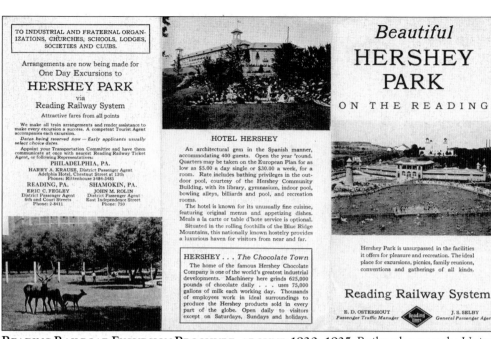

READING RAILROAD EXCURSION BROCHURE, AROUND 1930–1935. Railroads across the United States sought ways to develop weekend travel. As Hershey Park developed, the railroad offered special excursion trains to the park from Harrisburg, Lebanon, Lancaster, and beyond at reduced rates. Hershey Park quickly became the destination of choice for hundreds of businesses, churches, and entire towns who organized group days at the park. (Courtesy of Donald Rhoads.)

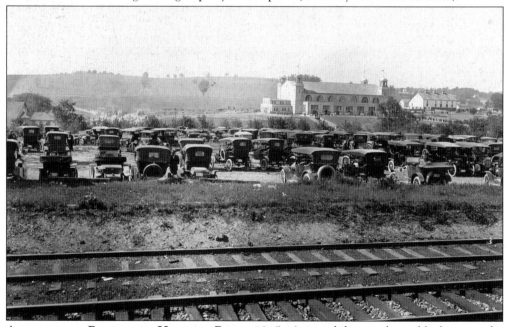

AUTOMOBILES PARKED AT HERSHEY PARK, 1915. Automobile travel quickly became the preferred means of transportation during the early 20th century. When the Convention Hall hosted special concerts, thousands of people came to hear performers such as Marion Talley and the Sistine Chapel Boys Choir.

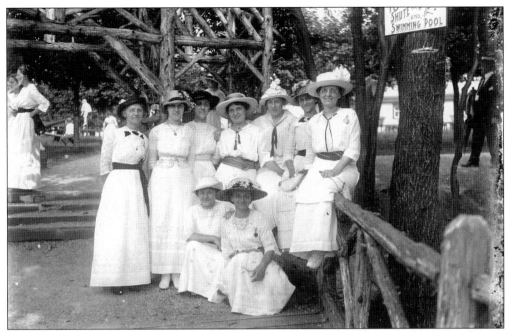

HERSHEY PARK PORTRAIT, C. 1915. When friends gathered together for a celebration at Hershey Park, a portrait from the park's photograph gallery could provide a permanent reminder of the day. This photograph was taken on the park's rustic bridge. Women dressed up in white dresses, and men wore suits to visit the park in its early years.

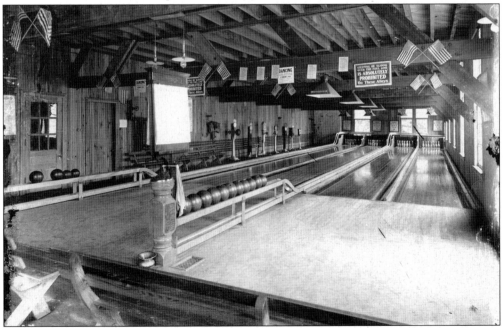

BOWLING ALLEY, AROUND 1909–1915. Built in 1909, the bowling alley was located across from the park's main pavilion, near Park Avenue. Its presence prompted local residents to rename a portion of the road "Bowling Alley Hill." The alley was one of the park's few attractions that was open year round.

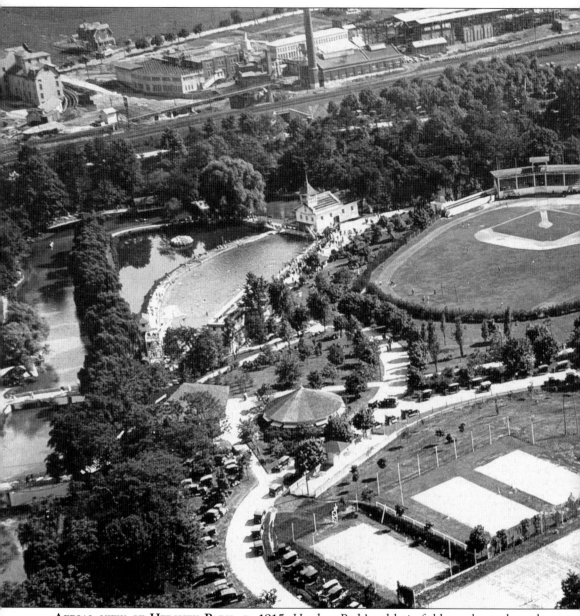

AERIAL VIEW OF HERSHEY PARK, C. 1915. Hershey Park's athletic field was located on the north side of Spring Creek. It was connected to the rest of the park by the miniature railroad. Hershey Park offered a variety of sports venues including a swimming pool, a baseball field with grandstands, and tennis courts. The open space surrounding the Convention Hall provided ample space for the thousands of people driving their automobiles to Hershey Park. The park's

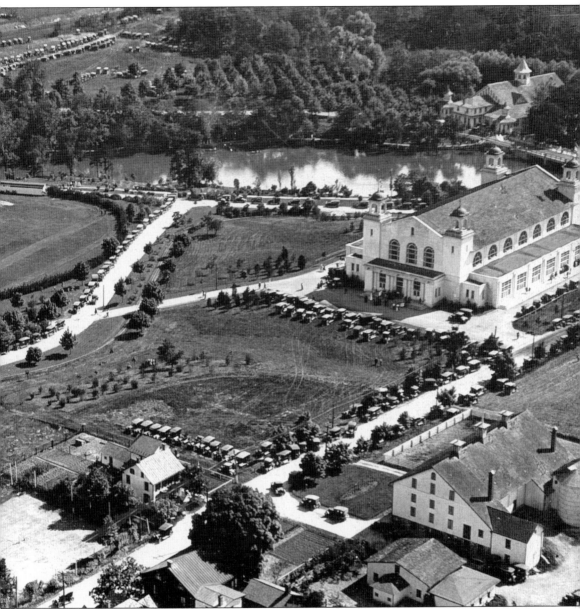

first carrousel was located in the circular pavilion located just above the tennis courts. The road passing in front of the Convention Hall is Derry Road, and Chocolate Avenue is visible in the top left corner of the photograph. In later years the barn visible in the lower right corner would be converted into the Parkside Apartments.

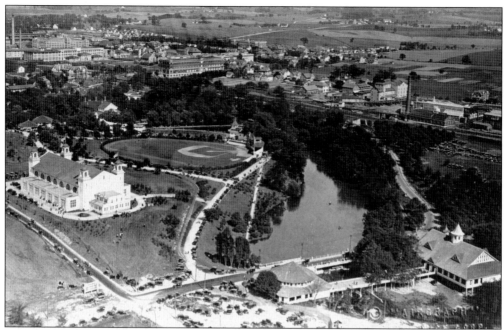

AERIAL VIEW OF HERSHEY PARK AND THE COMMUNITY, C. 1917. Land for the park was set aside as Milton Hershey planned his model town. Located close to the community's commercial area, the park was popular with residents and visitors. Park visitors also enjoyed visiting the town, shopping in the local stores and, of course, touring the Hershey Chocolate Factory.

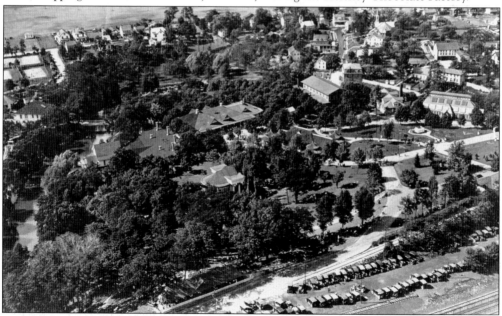

AERIAL VIEW OF HERSHEY PARK, LOOKING NORTH, C. 1917. Hershey Park's rides and entertainment attractions were concentrated in this part of the park. The park's many trees made it a cool and comfortable place to relax during the hot summer months. Through the trees the roof of the bandstand is visible in the center of the photograph. Pennsylvania Railroad formed the park's southern boundary.

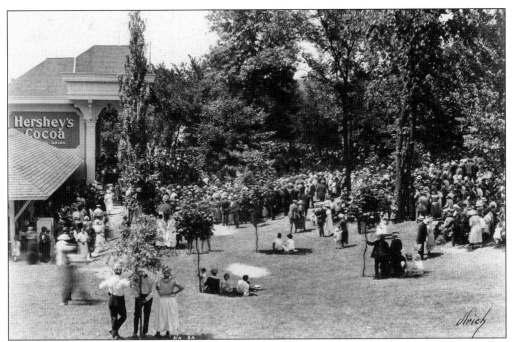

HERSHEY PARK BANDSTAND, C. 1930. This bandstand replaced a smaller one constructed in 1910. Initially the bandstand hosted free Sunday and holiday concerts given by the park's own band throughout the park season. This tradition continued until World War I, when the band lost too many members to the war effort.

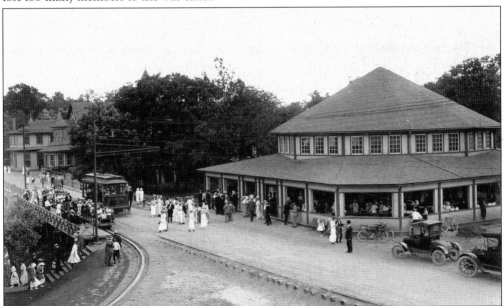

MINIATURE RAILROAD AND CARROUSEL, 1916. In 1912, Hershey purchased a new, larger carrousel from William Dentzel of Philadelphia. A new pavilion was constructed to house the new ride. The pavilion was much larger than the ride to allow room for people to sit inside and enjoy watching the ride. The new carrousel featured more than horses. It included a lion, a tiger, a deer, rabbits, goats, bears, pigs, and others for a total of 13 different animals.

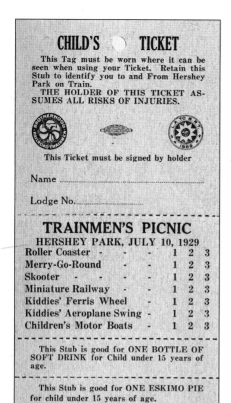

CHILD'S TICKET

This Tag must be worn where it can be seen when using your Ticket. Retain this Stub to identify you to and From Hershey Park on Train.

THE HOLDER OF THIS TICKET AS-SUMES ALL RISKS OF INJURIES.

This Ticket must be signed by holder

Name ...

Lodge No.

TRAINMEN'S PICNIC
HERSHEY PARK, JULY 10, 1929

Roller Coaster - - -	1	2	3
Merry-Go-Round - -	1	2	3
Skooter - - -	1	2	3
Miniature Railway -	1	2	3
Kiddies' Ferris Wheel -	1	2	3
Kiddies' Aeroplane Swing -	1	2	3
Children's Motor Boats -	1	2	3

This Stub is good for ONE BOTTLE OF SOFT DRINK for Child under 15 years of age.

This Stub is good for ONE ESKIMO PIE for child under 15 years of age.

TRAINMEN'S PICNIC TICKET, JULY 10, 1929. As part of the park's picnic services, businesses could purchase special tickets to provide a variety of activities to attendees at no cost to them. The tickets were specially printed for each picnic and tailored to meet the needs of each group. This ticket permitted the holder to ride the listed rides up to three times each. The tickets could also be used to get treats from the concession stands. (Courtesy of Neil Fasnacht.)

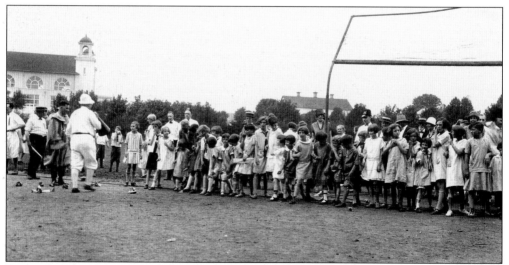

PICNIC DAY RACES, AROUND 1920–1935. Town and business picnic days often featured a variety of sporting competitions between the attendees. The adults often participated in an afternoon baseball game. A variety of races were organized for the children including three-legged races, egg tosses, sack races, and relay races. Hershey Park Day became a popular tradition repeated annually for many groups and businesses. (Courtesy of Neil Fasnacht.)

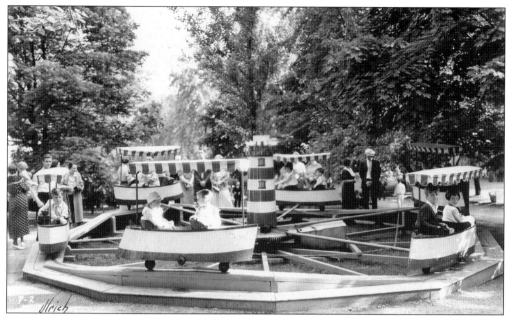

KIDDIE BOAT RIDE, AROUND 1930–1935. Rides specially designed for children began to be added to Hershey Park beginning in 1926. That same year, Hershey Park featured its first kiddie day. It was eventually expanded to a full week held at the end of August each year. Children 12 years old and younger could register and receive a ticket that would give them free rides and special treats.

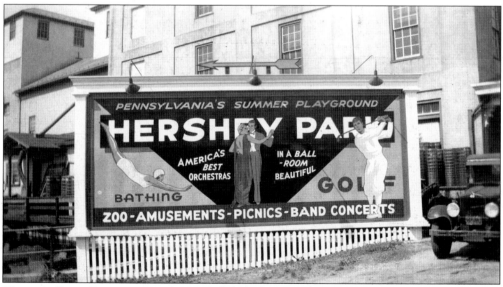

HERSHEY PARK BILLBOARD, C. 1935. While Milton Hershey may have not used the media to sell his chocolate products, advertisements such as this were frequently used to promote the park. Hershey Park was promoted as a daylong destination with activities designed to appeal to visitors of all ages. (Courtesy of Neil Fasnacht.)

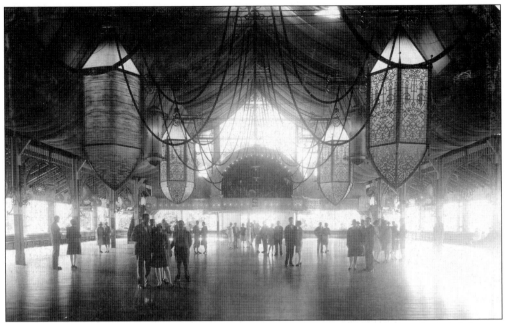

HERSHEY PARK BALLROOM, C. 1924. Hershey Park began offering regularly scheduled dances in 1910. In 1917, a new facility for dancing was built along Park Boulevard close to the new carrousel pavilion. At first the ballroom's orchestra platform was elevated and located at one end of the dance floor. Later it was moved to the center of the long wall.

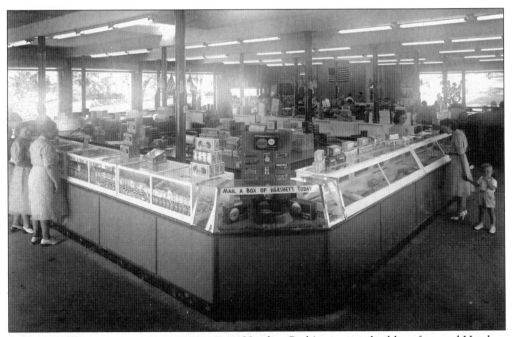

SOUVENIR BUILDING, AROUND 1939–1941. Hershey Park's souvenir building featured Hershey chocolate products for sale in addition to the more traditional park souvenirs. On the outside of the building, food stands on each corner of the building sold saltwater taffy, popcorn, drinks, and ice cream.

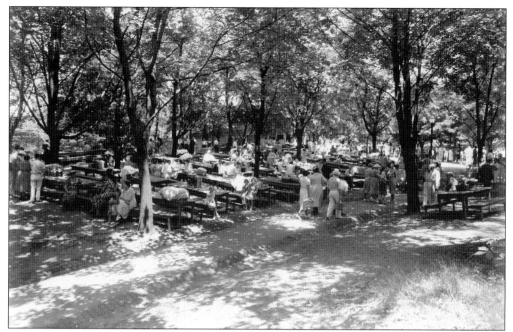

PICNIC GROUNDS, AROUND 1945–1955. Picnic tables and pavilions dotted the park grounds. Families coming to the park planned on spending the entire day and packed food for two meals in wicker baskets covered with a tablecloth. Often someone would come early to the park to place the family picnic basket on a table to reserve a spot for the day.

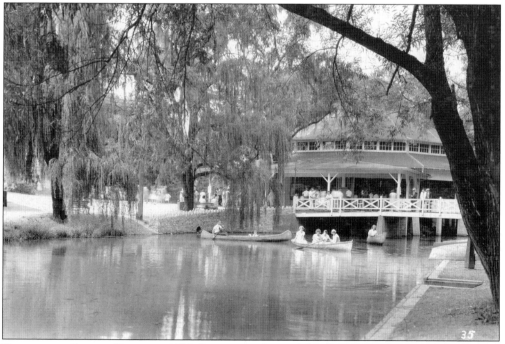

BOATING ON SPRING CREEK, C. 1933. Boating on the creek has been a popular pastime in the park during its entire history. Paddling along the creek, boaters could see most of the park's attractions, such as the carrousel pictured here. Boating was one of the park's more simple pleasures.

PHILADELPHIA TOBOGGAN COMPANY CARROUSEL NO. 47, C. 1950. Milton Hershey purchased a new carrousel for the park in 1944. Constructed in 1919 for Baltimore's Liberty Heights Park, the carrousel incorporated a patriotic motif with American flags, and Miss Liberty featured on the outer rim. The carrousel was a four-row model with 66 horses, much larger than the Dentzel carrousel it replaced. The Dentzel carrousel was sold to Knotts Berry Farm in California.

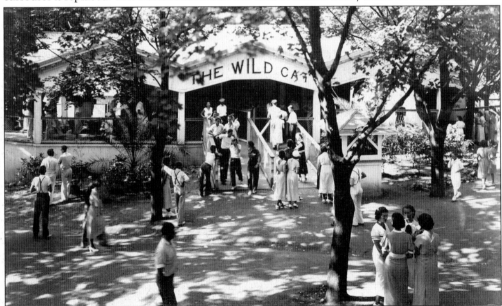

WILD CAT ENTRANCE, C. 1924. Initially, Hershey Park's first roller coaster was called the "Joy Ride." Within a short time its name was changed to the "Wild Cat." *Hershey Press* wrote that the roller coaster had cost $50,000. Up to this time, park rides had not operated on Sundays. However, the park saw its largest crowds that day. With the addition of this costly ride, the park began operating its rides on Sundays.

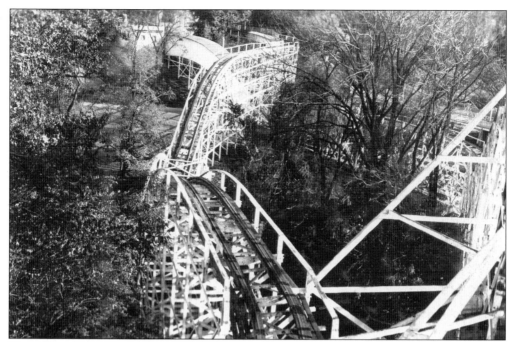

THE WILD CAT, C. 1925. The Wild Cat was the first coaster designed by the great coaster designer Herbert P. Schmeck. Before this project he had built several coasters for the Philadelphia Toboggan Company serving as construction manager. Philadelphia Toboggan Company ran the Wild Cat as a concession for a number of years. The coaster was 76 feet high and crossed Spring Creek on a specially designed wooden bridge. Schmeck was never really satisfied with the design, and it was modified in the 1920s. In 1935, it was redesigned to make its dips higher and the curves more steeply banked.

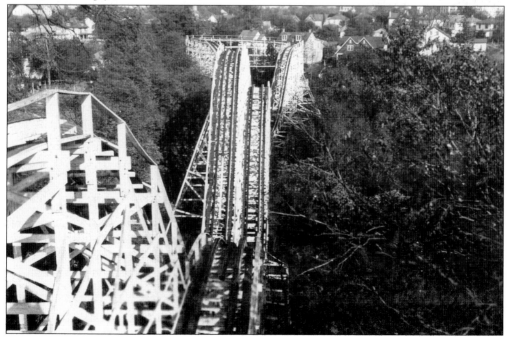

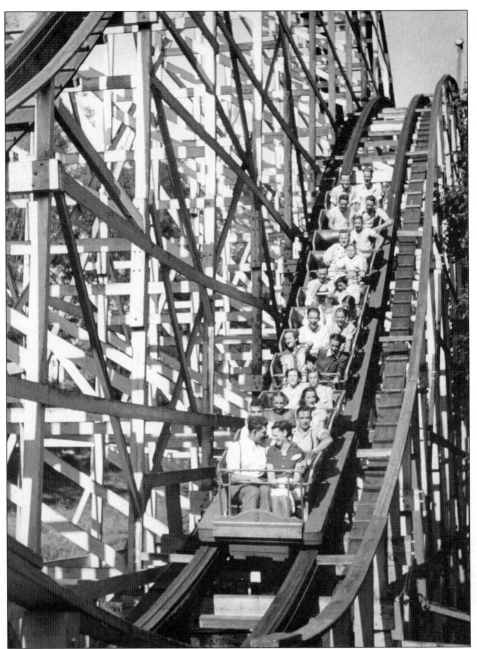

The Wild Cat, around 1940–1945. Hershey celebrated its 20th anniversary in 1923, and Milton Hershey's present to the town was a new roller coaster named the Wild Cat. The Wild Cat was nearly a mile in length, and it had "more dips and deeper dips than any of like construction in America." It was put into operation on June 16, 1923. On opening day, word quickly spread through the town that the coaster was operating and that rides were free. The town's youth came running to be among the first to ride the coaster. On its first day of operation no ladies were allowed to ride until the afternoon. Marion Murrie, daughter of Hershey Chocolate Company president William F. R. Murrie, was the first female to ride the coaster. The Wild Cat operated from 1923 to 1945, when it was replaced by the Comet.

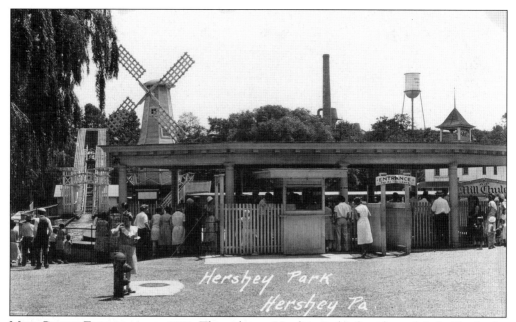

MILL CHUTE ENTRANCE, C. 1931. This ride was Hershey Park's first themed dark ride. In the old mill portion of the channel the ride had four animated scenes. The Mill Chute and the Wild Cat were managed as a Philadelphia Toboggan Company concession for many years. In spite of high costs of maintenance, the ride was very popular and significantly outearned the Wild Cat.

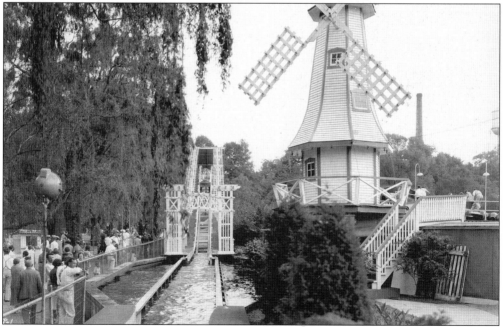

MILL CHUTE DESCENT, AROUND 1930–1935. Herbert Schmeck was also responsible for the design of the Mill Chute, a water flume ride. Like the Wild Cat, this ride was built and managed by the Philadelphia Toboggan Company. The ride featured a mill wheel to move water through the channel. Ride boats traveled through the channel and were pulled up by chain and then slid down the chute into a water pond.

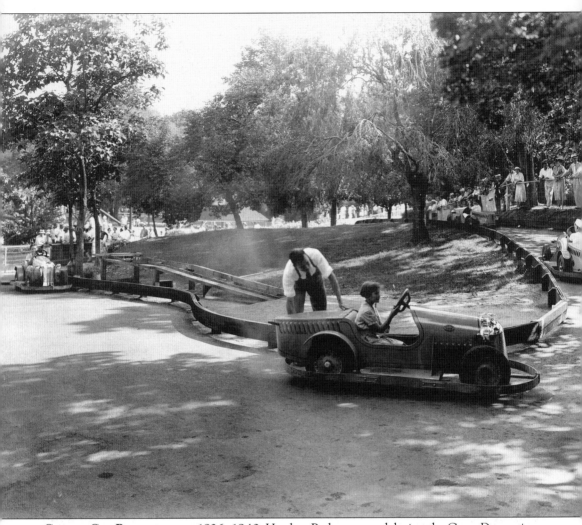

CUSTER CAR RIDE, AROUND 1936–1940. Hershey Park prospered during the Great Depression. Some of the park's most popular attractions were added then, including the Bug, a remodeled fun house, a Ferris wheel, and the Aerial Joy Ride. In 1936, Hershey Park added a new ride, the Custer Car Ride developed by Luzern Custer of Dayton, Ohio. It was a miniature automobile with a metal body, hard rubber tubeless tires, and four rechargeable batteries for power. Kids in particular loved the feeling of freedom and power experienced with this ride. The ride required a great deal of maintenance because drivers continually crashed the cars into the railings.

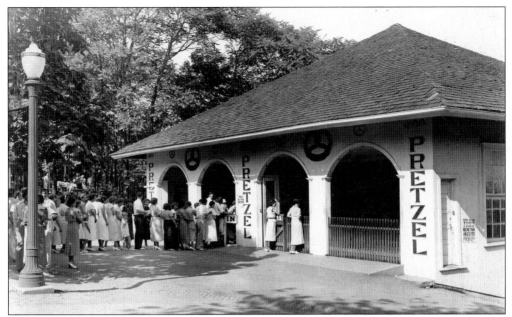

THE PRETZEL, C. 1935. Hershey Park's first dark ride was manufactured by Leon Cassidy of Bridgeton, New Jersey. The Pretzel had cars painted a fire engine red with golden counterweight pretzels made of cast iron on the sides. The boarding area featured painted white ghosts with a sign that read, "Fun, Thrills, and Chills." The ride took passengers on a twisting path past lighted stunts of snakes, ghosts, and scary faces.

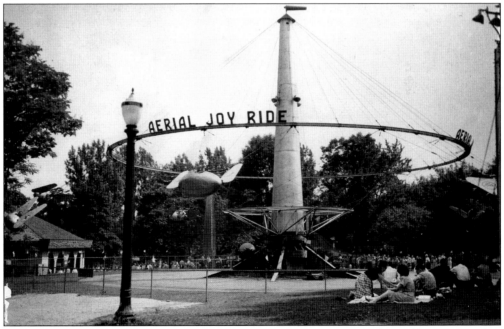

AERIAL JOY RIDE, AROUND 1950–1955. Following the 1939 New York World's Fair, Hershey Park purchased the Aerial Joy Ride from the fair. Opening in 1941, the ride was an immediate success. This ride would be the last addition to the park for several years since the United States would enter World War II in a few short months.

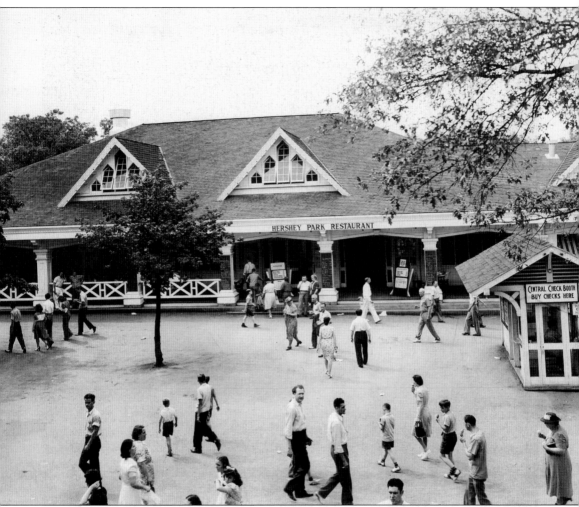

HERSHEY PARK RESTAURANT AND TICKET BOOTH, AROUND 1940–1945. Best remembered for its chicken and waffle dinners served on the veranda, the park restaurant's menu included beef and pork dinners, sandwiches, and pie and ice cream for dessert. Milton Hershey always ordered chicken and waffles when he ate in the park restaurant. After his meal, he would go back to the kitchen to thank the staff and compliment the cooks. All purchases in the park, including rides, food, and arcade games, were made with tickets purchased at the ticket booth.

KIDDIELAND, AROUND 1950–1960. As Hershey Park acquired more kiddie rides, they were grouped together forming a small Kiddieland. The rides were located on the north side of Spring Creek not far from the eastern end of the arena. In this section of the park all the rides cost a nickel. Special tickets could be purchased to provide children a trip on each ride.

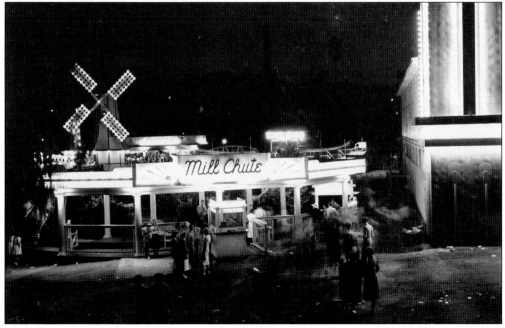

MILL CHUTE AT NIGHT, C. 1938. Hershey Park's use of neon lighting made the park a thrilling place to be after dark. All the rides were specially lit both outside on the signs and in the ride to add to the excitement. The entrance to the Mill Chute and the ride's tunnel section were both painted a pale green, and the neon lighting lit up in a soft pink color at night.

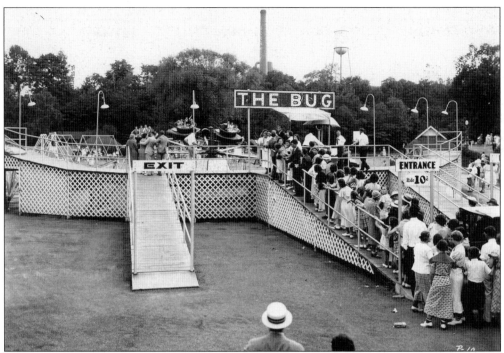

THE BUG, AROUND 1932–1940. In 1932, Hershey Park added one of its best remembered rides, the Bug. Purchased from Traver Engineering of Beaver Falls, Pennsylvania, the Bug featured six cars that traveled around a circular undulating track, in a counterclockwise rotation. The cars were painted to look like caterpillars. The ride threw its passengers from side to side adding to the excitement. Passengers could also spin themselves around as the cars rode along the track. The ride was located on the north side of Spring Creek near the new carrousel pavilion. Eventually the Bug was moved to Comet Hollow, where it operated until it was removed following the 1981 season.

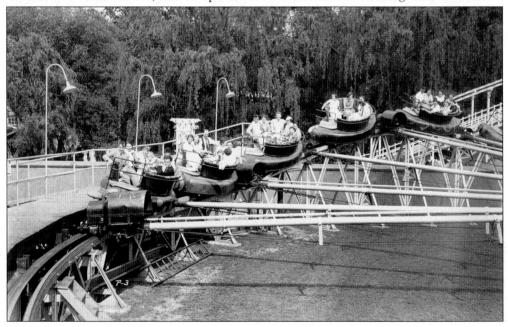

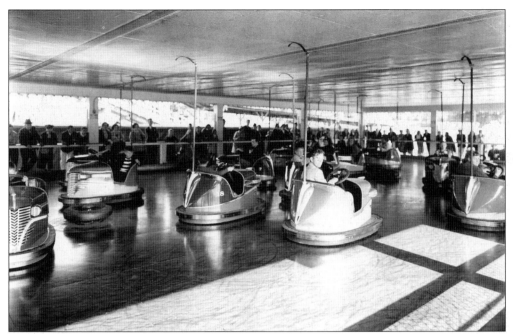

AUTO SKOOTER, AROUND 1938–1940. In 1926, Hershey Park purchased its first bumper car ride from Lusse Brothers of Philadelphia. The ride was located on the north side of Spring Creek, just across the bridge from the Wild Cat. In 1938, a new bumper car ride, the Auto Skooter, replaced it. The new ride was moved across the creek to the future Comet Hollow area.

THE WHIP, C. 1940. In 1937, Hershey Park purchased a Whip ride from the William Mangel Company of Coney Island, New York. The park had wanted to purchase the ride several years earlier but Hershey Chocolate Company's financial debt had restricted any desired park expansion at that time. Hershey Park's original Whip ride was removed to make way for the sooperdooperLooper. The park's current Whip was installed in 1997.

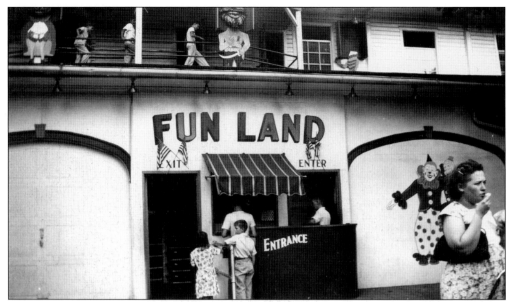

FUNLAND, C. 1950. Hershey Park's first fun house opened in 1930. In 1938, it was remodeled and renamed Whoops. It entertained visitors with shifting floors, revolving barrels, mirrors, and air holes. In 1946, the park built Funland, replacing Whoops, which had been torn down to make way for the Comet. (Courtesy of Neil Fasnacht.)

ENTRANCE TO THE COMET, AROUND 1955–1965. In 1946, the Wild Cat roller coaster was replaced with the Comet. Like the park's first coaster, this one was designed and constructed by Herbert Schmeck and the Philadelphia Toboggan Company. Hershey Park formed a joint partnership, the Associated Amusement Company, with the Philadelphia Toboggan Company, to manage the ride.

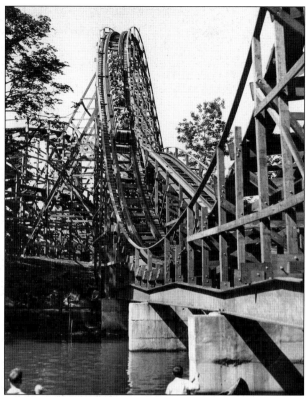

THE COMET, AROUND 1955–1965. One unique feature of this coaster is that it crosses Spring Creek twice during its 3,360-foot journey. A total of 248,919 feet of lumber was used to build the double out-and-back coaster. The Comet's first drop is 96 feet, and its second drop is 72 feet. The coaster crosses Spring Creek on a steel bridge and travels up a hill to Park Boulevard. The coaster was built so close to town that riders' screams can be heard on Chocolate Avenue. The coaster features a series of drops that curve as they descend on the third and fourth runs to create a more exciting ride. The ride's finish is a series of hills or bunny hops with a turnaround to the brake curve and loading station.

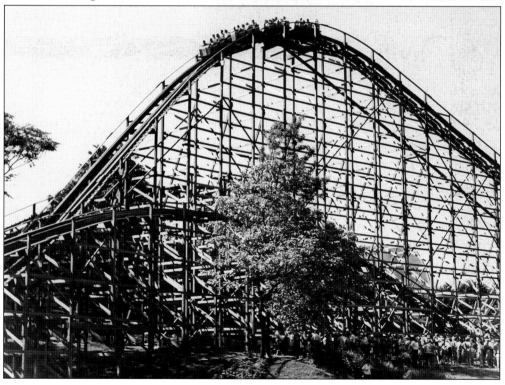

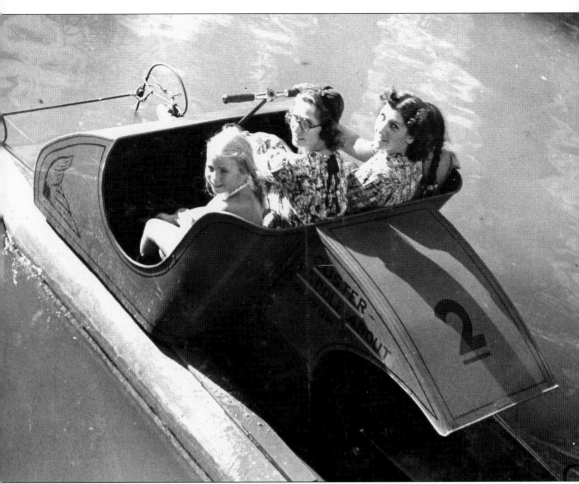

CUSTER BOAT RIDE, AROUND 1940–1945. Boating on Spring Creek was a popular pastime at Hershey Park from its beginning. A variety of boats have appeared on the creek over the years, including canoes, rowboats, and a variety of paddleboats. The Custer Boat was invented by Levitt Luzern Custer, the same man who had sold Hershey Park its first turnpike ride. The small, paddle wheel–propelled water craft worked on the same principle as a bicycle, with pedals turning the paddle wheel in back.

Two

SOMETHING FOR EVERYONE

PARK ENTERTAINMENT

Hershey Park offered much more than a simple group of amusement rides. The scope and diversity of entertainment options set Hershey Park apart from its competitors. The park was an integral part of Milton Hershey's model town and was the primary venue for the community's recreation and relaxation. Town residents as well as visitors made use of the park's facilities.

From the beginning the park's sporting fields were put to heavy use. Baseball, football, and basketball were all played on park grounds to enthusiastic audiences that packed the stands to cheer the local favorites. Golf also had its enthusiasts in town. The earliest community golf course was established in 1908. As the town developed as a tourist destination, new golf courses were developed. Park facilities expanded to include the Hershey Park Golf Course and Clubhouse.

Milton Hershey saw his model town and its amenities as a natural way to promote interest in his chocolate products. Additions and improvements to the town became marketing tools for promoting Hershey's chocolate. Beginning about 1909, specially sized postcards were inserted inside the wrappers of standard size milk chocolate bars. These postcards featured scenes of the town, including Hershey Park. The postcards were also used to market the park as a destination for businesses and church groups seeking a venue for their summer picnics.

Offering a variety of entertainment was important to Hershey Park's success. The year 1909 was a turning point for the park. Several new attractions were added, including a new bandstand, used for weekly community band concerts and the amphitheater for vaudeville. Over the years the bandstand would become a major entertainment venue for the park, presenting weekly Sunday afternoon concerts by both locally and nationally known groups such as the Allentown Band, Red McCarthy and his band, and all the United States military service bands.

Hershey's reputation as a major destination was established in 1915 with the construction of the Convention Hall. Built as an inducement for the Church of the Brethren to hold its triennial convention, the hall seated 6,000 people. Recognizing that Hershey had become a popular destination, the Hershey Visitors Bureau was also established in 1915 to coordinate the growing demand for factory tours and other services.

In 1931, the Convention Hall was modified to permit ice-skating in the winter months. An ice plant and a rink was installed. A Hershey Park facility could now be used all year long. The community's interest in skating was contagious. In 1931, the Swarthmore Hockey Club began playing its games in Hershey. Hershey's enthusiasm for hockey and ice-skating soon made the Ice Palace too small for all those wanting to attend hockey games. On several occasions hundreds of people were turned away due to lack of space.

The need for a larger ice arena was obvious. This need, coupled with Milton Hershey's love of innovation, led to the construction of the Hershey Park Sports Arena, noted for its innovative design. When it opened on December 19, 1936, the sports arena was the first large-scale barrel-shell-roof structure in the United States. In addition to serving as home ice for the

American Hockey League (AHL) Hershey Bears hockey team, the sports arena enabled the park to extend its season, providing enclosed space for a variety of sporting and performance events.

Hershey Park Stadium, completed in 1939, also enabled the park to broaden its entertainment opportunities. It was originally designed to host midget automobile races, an extremely popular sport first introduced in the United States in 1933. The stadium was also used as a venue for a variety of events, including football games, concerts, and rodeos.

One of the first buildings built for the park was a multipurpose hall used for dances and other types of gatherings. Dancing was a popular form of recreation, and Hershey Park soon built a facility dedicated to dances. At first Hershey Park booked local bands for the Saturday night dances, but beginning in 1926, nationally known dance bands began to play at Hershey Park Ballroom. The ballroom was a major touring venue for every national big band through the 1950s.

The ballroom closed for a few years during World War II because of gas rationing, but quickly reopened when restrictions were lifted. While initially successful in the postwar years, by the mid-1950s the ballroom was faltering. Attendance was declining, and the audience was aging. Big band dance music was giving way to rock and roll.

During the winter of 1957, the ballroom roof collapsed under a particularly heavy snow. In an effort to save money while attempting to reenergize ballroom dancing, the ballroom was repaired without replacing the central portion of the collapsed roof. The Starlight Ballroom was launched and promoted dancing under the stars. While it initially enjoyed some modest success, the days of ballroom dancing were coming to an end.

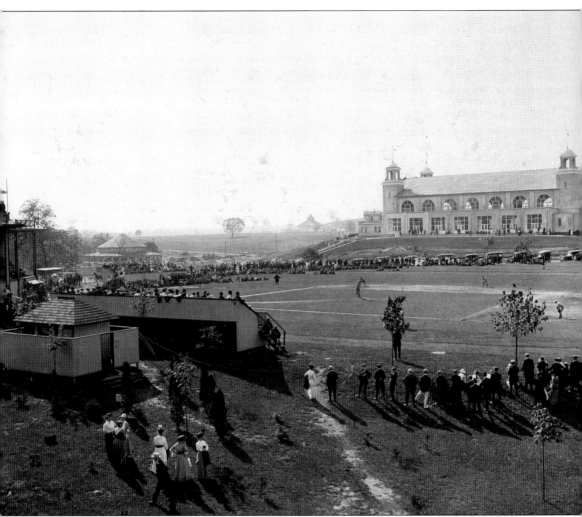

HERSHEY PARK ATHLETIC FIELD, 1915. When he established the town in 1903, Milton Hershey provided for the community's recreational needs by creating opportunities and facilities for sports and athletic events. Soon after the Hershey Chocolate Factory opened in 1905, baseball teams were quickly organized by factory workers and residents. The community's first baseball team was assembled by John Snavely. The teams were sometimes small in the early years, but the games played on the Hershey Park Athletic Field were often attended by large and enthusiastic crowds. Spectators packed the grandstands to watch Hershey take on teams from Elizabethtown, Lebanon, Harrisburg, and their intense rivals, Palmyra. The *Hershey Press* covered the games, offering highlights as well as batting and fielding averages and league standings.

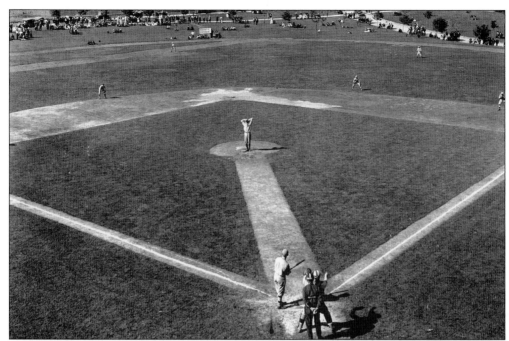

PLAYING BASEBALL AT THE ATHLETIC FIELD, AROUND 1912–1915. William F. R. Murrie, Hershey Chocolate Company president, managed many of the early baseball teams. As a young man, Murrie had played in a semi-professional league as a pitcher. Players were drawn from the employees and community residents. Several players were also recruited from the Carlisle Indian School. American Indian students worked in the chocolate factory in the summer and played on Hershey baseball other sports teams during their stay. The Carlisle students came to Hershey because of a personal friendship between Bill Murrie and Glenn "Pop" Warner, the Indian School's football coach.

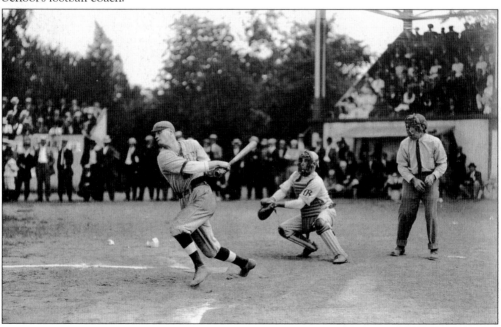

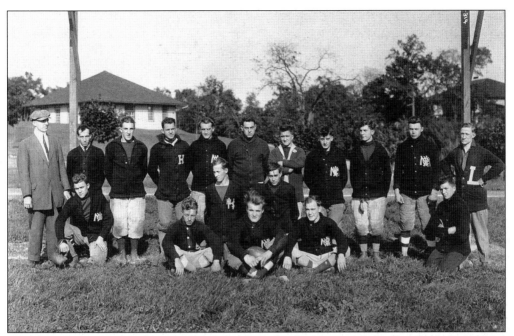

HERSHEY FOOTBALL TEAM, C. 1915. John Snavely also organized the first football teams in Hershey. The first football game took place around 1905 and was played between Hummelstown and Hershey. The first playing field was located on the corner of Chocolate and Cocoa Avenues. By 1907 a football field had been laid out near Hershey Athletic Field baseball diamond.

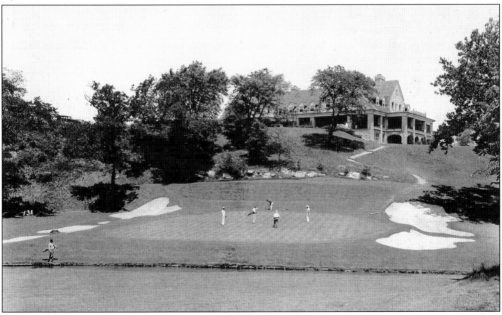

HERSHEY PARK GOLF COURSE AND CLUBHOUSE, AROUND 1940–1950. Hershey Park Golf Course opened in 1929. It was designed by famed golf course architect Maurice McCarthy, who also designed the Hershey Country Club's West Course, and the nine-hole Spring Creek Golf Course. This course featured 18 challenging holes with lots of changes in elevation and a meandering stream.

HERSHEY PARK
Attractions

MOTION PICTURES
PARK THEATRE CLOSES FOR SEASON—SATURDAY—SEPT. 10
CLOSING ATTRACTION, FRIDAY & SATURDAY, SEPTEMBER 9th & 10th.
"NEW MORALS FOR OLD," with Lewis Stone

LITTLE THEATRE opens Tuesday, September 13th
MOVIES EVERY TUESDAY, THURSDAY and SATURDAY—Admission, Adults, 25c
Children 10c — TWO SHOWS EACH EVENING AT 7 o'clock and 9 o'clock.

Tuesday—September 13th	Thursday—September 15th
MR. & MRS. MARTIN JOHNSON in	"ALMOST MARRIED"
"CONGORILLA"	with
	VIOLET HEMING & RALPH BELLAMY

DANCING

Saturday—September 10th	Saturday—September 17th
"Battle of Music"	GUY LOMBARDO
DICK MOUL and his WELDON HALL ORCHESTRA	and his
vs.	
JOHNNY DIEHL	ROYAL CANADIANS
Admission 50c	

FREE OPEN AIR CONCERT !
SUNDAY SEPTEMBER 11th–2 to 4 P. M.
The Famous Allentown Band

FREE MOVIES AT BAND SHELL—SUNDAY, SEPTEMBER 11th, 8 O'CLOCK P. M.
"The Gift of Montezuma" in Sound and Technicolor
A Picture of Hershey and its Industries.
The Pool Will Be Open As Long As Weather Permits.

ADVERTISEMENT, 1932. Hershey Park marketed itself as offering a broad range of attractions, from dancing to movies. Park advertisements promoted other venues in town, advertising movies playing at the community center as well as in the park itself. Hershey Park was one part of a much larger group of community attractions that made Hershey an entertaining and popular destination for visitors. (Courtesy of Neil Fasnacht.)

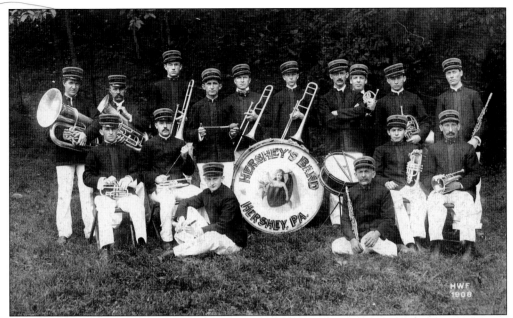

HERSHEY PARK BAND, 1908. The first band members were recruited from factory employees and town residents. Musical talent was not a prerequisite. Milton Hershey supplied the band with its uniforms and instruments. In the beginning the band was more noted for its "vim and persistence" rather than its musical sound. Until World War I the band gave two concerts each Sunday during the park season. (Courtesy of Neil Fasnacht.)

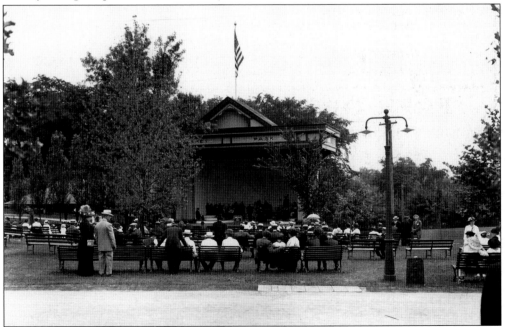

HERSHEY PARK BANDSTAND, C. 1915. In 1914, Milton Hershey had a new larger bandstand constructed near the park's main entrance. It was more than twice as large as the old bandstand and could accommodate up to 60 musicians. Milton and Catherine Hershey enjoyed band music and often attended the band's Sunday concerts. (Courtesy of Neil Fasnacht.)

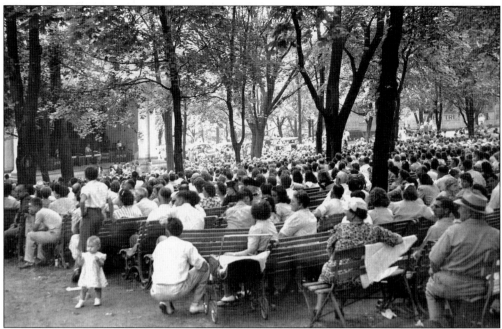

HERSHEY PARK BAND CONCERT, AROUND 1950–1960. Free band concerts were part of the park's regular entertainment schedule. Different local bands were hired to provide band music throughout the summer months. On major holidays well-known bands such as the Allentown Band, the United States Navy Band, and the United States Marine Band performed at the bandstand.

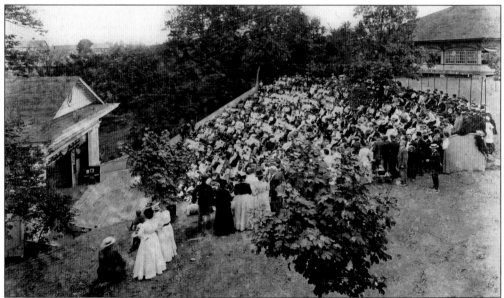

HERSHEY PARK AMPHITHEATRE, 1909. Taking advantage of the natural terrain, Hershey constructed an amphitheater with seating for 1,500. It was located adjacent to the park's main pavilion. Hershey Park booked vaudeville shows that changed once a week for the amphitheater. After the first year, a 10¢ fee was charged for a seat in the outdoor theater. In addition to live entertainment, the amphitheater was also used at night to show motion pictures.

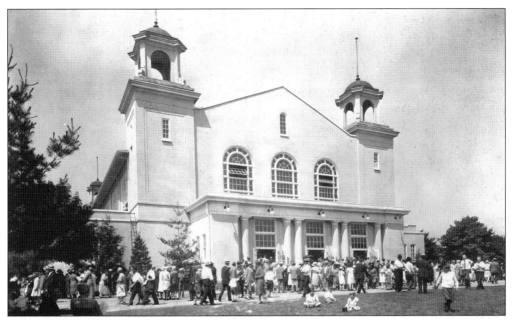

CONVENTION HALL, 1930. The Convention Hall was originally conceived as a Chautauqua hall, which would offer a wide array of educational and cultural opportunities. It served Hershey not only as a meeting place but also as a performance hall. Between 1915 and 1930, noted artists such as John Philip Sousa, the Bethlehem Bach Choir, Will Rogers, and the Great Creatore performed at the Convention Hall.

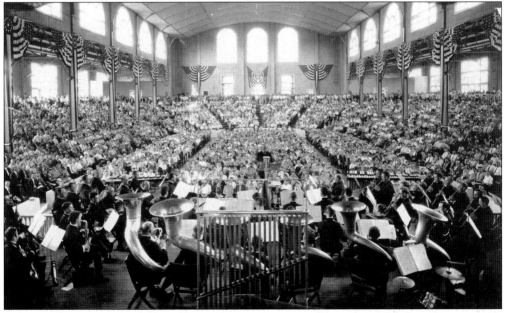

CONVENTION HALL INTERIOR, 1925. The Convention Hall was remodeled, and its acoustics were improved for the 1925 season. That year John Philip Sousa and his band performed at the Convention Hall over the Fourth of July weekend celebration. Tickets for his afternoon and evening concerts were 75¢. There was standing room only for the concert, and many more people crowded around the building listening to the band.

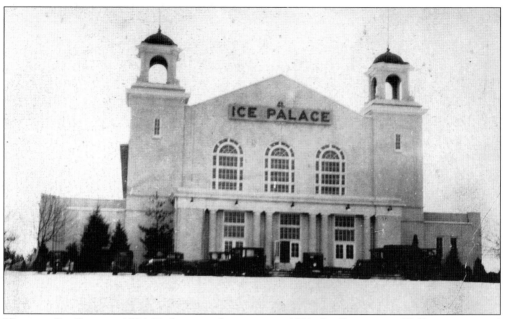

HERSHEY ICE PALACE, 1931. Each winter, beginning in 1931, the Convention Hall was converted to an ice rink. The original ice surface measured 60 by 170 feet. The rink was used for public skating, an annual ice carnival, and hockey games. The first hockey team to call Hershey home was the Swathmore Athletic Club. Hockey became so popular that the rink was remodeled to provide a larger ice surface.

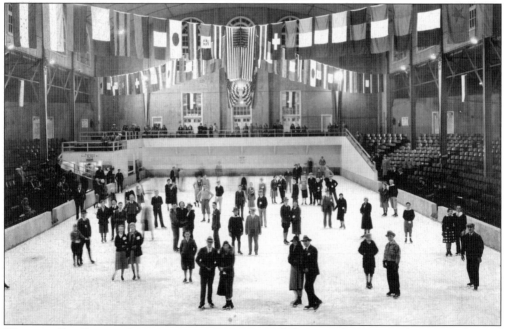

HERSHEY ICE PALACE INTERIOR, 1931. It appeared that Hershey was in love with skating. Visitors and residents flocked to skating events. The annual Hershey Skating Club Ice Carnival, first launched in 1934, attracted thousands of spectators, and often completely sold out weeks in advance, with hundreds more turned away each performance night.

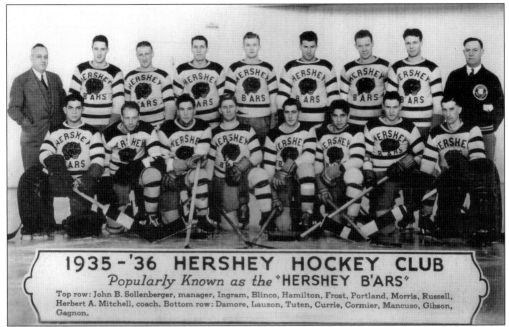

HERSHEY B'ARS HOCKEY CLUB, 1935. Hershey organized its own hockey club for the 1932–1933 season. The club was a member of the newly formed Tri-State League, and competed against teams from Baltimore, Atlantic City, and Philadelphia. The Hershey hockey club was named the Hershey B'ars, and the team colors were maroon and silver, just like the famous Hershey bar.

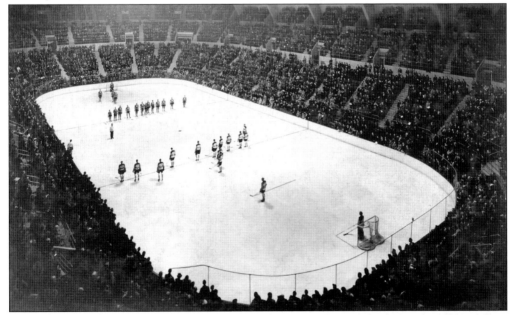

HERSHEY PARK SPORTS ARENA, 1936. According to Brent Hancock, the team's publicist from 1935 to 1982, New York sportswriters objected to the team's name. They refused to use the team name in writing about hockey games. In addition, when Hershey later joined the American Hockey League in 1938, the league did not want its teams to carry the name of a commercial product. So beginning with the 1938–1939 season, the club's name was modified to the Hershey Bears.

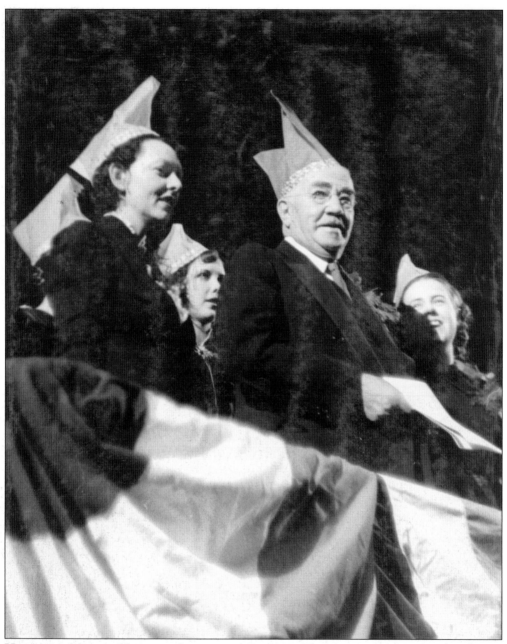

HONORING MILTON HERSHEY, SEPTEMBER 13, 1937. The sports arena was used to host a variety of large-scale events. In 1937, the Hershey community came together at the sports arena to honor Milton Hershey and celebrate his 80th birthday. The celebration included vaudeville entertainment, dancing, and refreshments. As a memento, every guest received a boxed slice of birthday cake. The employees took up a collection to purchase Milton Hershey a birthday gift. The main gift was a specially designed ring featuring the company trademark of a baby in a cacao pod, encircled with diamonds.

DONNA ATWOOD AND THE ICE CAPADES, 1955. The sports arena regularly hosted a number of ice shows each year including the Ice Follies and the Ice Capades. Donna Atwood joined the Ice Capades after winning the Pairs gold medal at the 1941 United States Figure Skating Championships. In 1955, Hershey Sports Arena premiered the new Ice Capades show featuring Donna Atwood.

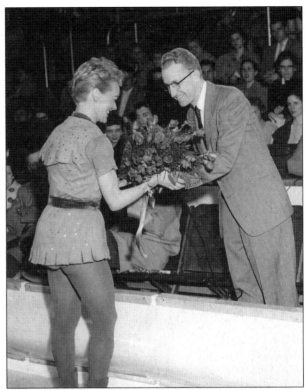

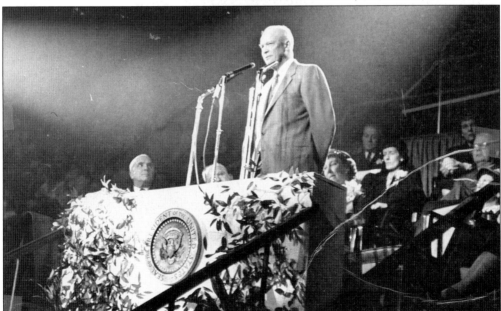

CELEBRATING PRESIDENT EISENHOWER'S BIRTHDAY, OCTOBER 13, 1953. That year Hershey hosted a 63rd birthday party for Pres. Dwight D. Eisenhower, sponsored by the Pennsylvania Republican Finance Committee. The final event of the celebration was held in the arena. The tribute featured a 45-minute pageant, produced by Fred Waring, entitled *The Song of America*, a musical saga tracing the founding and development of America.

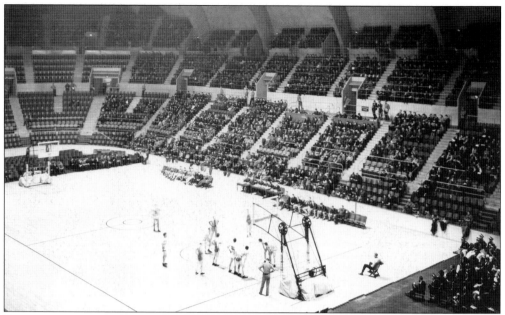

BASKETBALL GAME, AROUND 1965–1975. In addition to hockey, the arena hosted a wide array of sporting events, including roller hockey, tennis, wrestling, and basketball. On March 2, 1962, Hershey Sports Arena was host to a historic basketball game between the Philadelphia Warriors and the New York Knickerbockers. At that game, Warrior Wilt Chamberlain scored 100 points, a record that has never been broken.

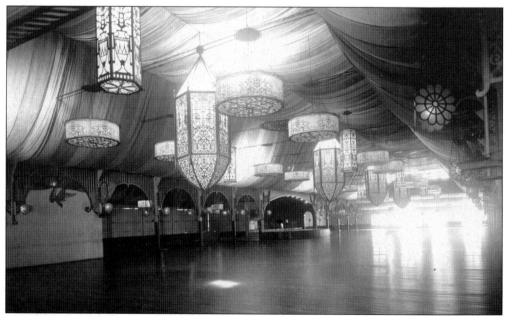

HERSHEY PARK BALLROOM, 1932. Many people have fond memories of the ballroom and dancing to the big bands. Ladies dressed up in long dresses, and the men had to wear a tie and jacket. The ballroom would sell men a tie if they had forgotten to put one on. Dances always started at 8:30 p.m. and ran until 12:30 a.m. except when Guy Lombardo performed. Then the time shifted to 9:00 p.m. to 1:00 a.m.

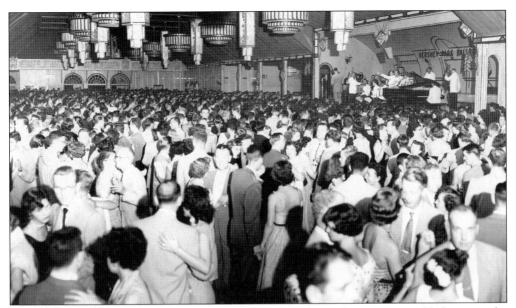

PEOPLE PACK THE DANCE FLOOR, 1953. Every Saturday night patrons could dance to the tunes of big bands such as Harry James, Glenn Miller, Vaughn Monroe, and Jimmy and Tommy Dorsey. Wednesday night dances were also held with music provided by local bands such as Red McCarthy, Frankie Hanshaw, and Jimmy Livingston. The dances were so popular that actually dancing was sometimes a problem in spite of the ballroom's generous dimensions: 190 by 40 feet.

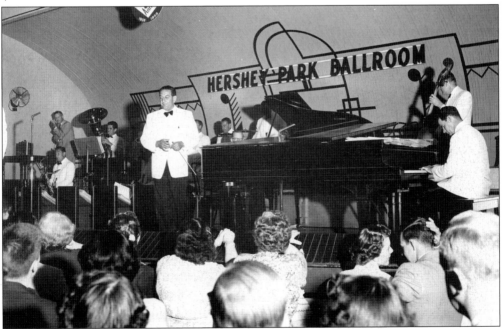

HERSHEY PARK BALLROOM, 1953. Guy Lombardo and his Royal Canadians performed at the ballroom in 1953 as part of the community's 50th anniversary celebration. All the big bands enjoyed performing in Hershey. Performers such as Harry James would come early to have time to play a few innings of baseball before their show.

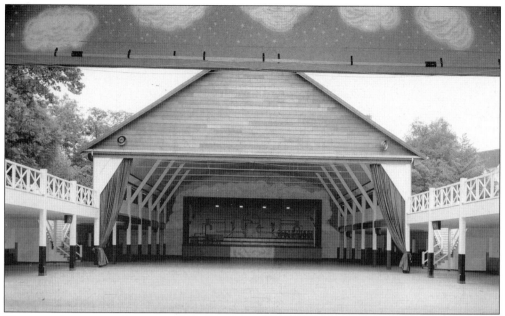

HERSHEY STARLIGHT BALLROOM, 1957. The ballroom was remodeled for the 1957 season to permit dancing under the stars. The terrazzo floor was installed in the open section of the dance floor while the two ends retained a polished wood surface. Other changes included a second-floor promenade area, refreshment stands, and an improved sound system that carried music to all parts of the building.

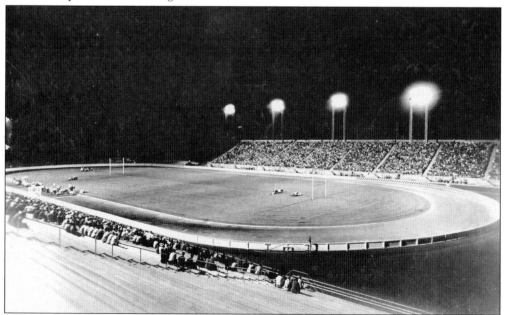

HERSHEY PARK STADIUM, 1939. The last major addition to the park complex during Hershey's great building campaign was a 16,000-seat stadium completed in the spring of 1939. The stadium offered midget automobile racing on Monday and Thursday nights. Fans thronged to see the small, fast cars on the stadium's quarter-mile track. In addition, the stadium hosted local football games and the Pennsylvania State Police Academy's annual rodeo.

Three

MORE THAN JUST RIDES
PARK ATTRACTIONS

Part of Hershey Park's appeal lay with the broad range of attractions that it offered to visitors. Many of these attractions would have been popular in their own right in other towns. Hershey Park provided a broad range of engaging and entertaining experiences that made a visit to Hershey appealing to families of all ages.

Hershey Zoo formally opened in 1910. It offered a broad range of animal exhibits ranging from the common to the exotic. On a visit to Hershey Zoo, visitors could see lions, monkeys, and leopards, as well as exotic reptiles and birds. With the advent of World War II, Hershey Zoo closed on December 20, 1942, and remained closed until it reopened on May 7, 1950. In addition to a broad range of animal exhibits, the zoo now included a diversified wildlife education exhibit sponsored by the Pennsylvania Game Commission. The education exhibits featured a wide array of mounted animals, with each exhibit designed to illustrate a particular aspect of Pennsylvania wildlife.

The park's first concrete swimming pool was added in 1911. Completed in the fall, the pool served as an ice-skating rink that winter and opened for its first swimming season in 1912. It was enlarged in 1915 and a "Shute the Shoots" water toboggan ride was added.

Swimming was so popular that a new expansive pool complex was added to the park in 1929. Its construction added to Hershey's reputation as "Pennsylvania's Summer Playground." By the 1940s more than 100,000 people visited the pool each summer. Adjacent to the new swimming pool, Hershey Park created the Sunken Garden used by sunbathers during the day and ballroom patrons during the evening hours. The Sunken Garden was popular with those without enough money for admission to ballroom dances. On summer nights dance music filled the air in the Sunken Garden as people strolled the paths.

Hershey Park used a variety of celebrations to attract guests and make the park inviting to return to again and again. In 1929, Hershey Park inaugurated a Kiddie Week that was held each year in late August. During that week children 12 years old and younger could register to obtain free rides and lollipops. Special entertainment was scheduled at the bandstand for the week.

Hershey Park inaugurated its baby parade in 1936 as part of its Kiddie Week celebration. The parade began at the miniature railroad station as children under five years old either walked or rode on parade throughout the park and concluded by crossing the bandstand floor to music provided by the Hershey Community Theatre Orchestra.

One of the park's more successful ventures, Pennsylvania Dutch Days, introduced in 1949, quickly grew into a weeklong event. Dutch Days was an appeal for nostalgia, looking back on old traditions that were rapidly ending in modern society.

Pennsylvania Dutch Days grew out of a Pennsylvania Dutch language class held during the winter of 1948–1949 as part of the Derry Township evening school. Upon completion of the course in the spring of 1949, the class suggested holding a gathering in Hershey Park for one day that summer to thank leaders responsible for offering the class. It soon grew into a weeklong special event, filled with food, crafts, and entertainment.

Milton Hershey wanted to provide a broad array of attractions for his community. In 1933, he opened the Hershey Museum, first known as the Hershey American Indian Museum. A few years later, Milton Hershey purchased a collection of Pennsylvania-German artifacts for his

museum. This purchase caused the museum to be moved to the old Convention Hall, empty since the arena had been constructed. Moving the museum to the park complex broadened the range of attractions available to park visitors. The museum also helped to lengthen the tourist season since it operated year round.

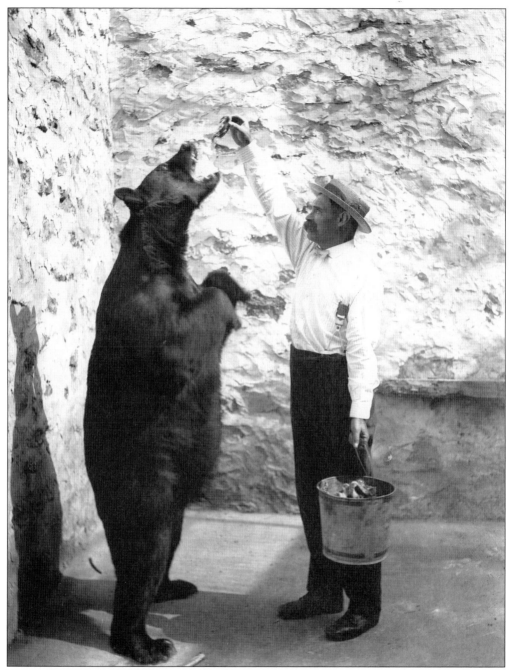

FRANZ ZINNER AND BOB THE BEAR, C. 1910. After Franz Zinner received a black bear cub from friends living out west, he went to speak to Milton Hershey about placing the bear in Hershey's new zoo. Milton Hershey hired Franz Zinner to come and manage the zoo. Zinner's experience in capturing African wild animals for circuses gave him the necessary skills to manage the new zoo. In the era before television, zoos such as Hershey's played an important role in educating the public about animals and environments different from central Pennsylvania. Zinner served as the zookeeper until his death in 1918.

PONY RIDES AT HERSHEY ZOO, AROUND 1910–1915. The early zoo offered a variety of animal exhibits including prairie dogs, goats, opossums, rabbits, pheasants, and zebus. These animals came to the zoo through donations and purchases. Some of the animals were treated more like circus performers. The zookeepers taught them tricks that they performed for zoo visitors. (Courtesy of Neil Fasnacht.)

BABY LIONS AT HERSHEY ZOO, APRIL 1936. The birth of lion quintuplets was big news in Hershey in 1936. Hershey Zoo was particularly successful breeding a wide variety of animals under its care. The offspring were sold or traded to other zoos in exchange for new animals that would expand Hershey's collection.

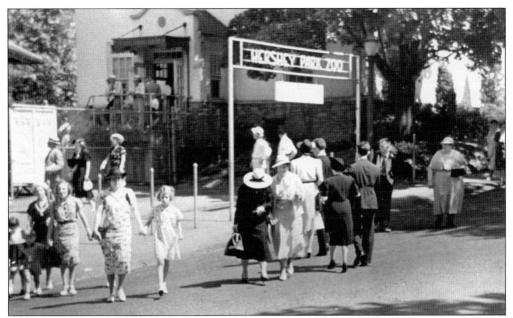

HERSHEY ZOO ENTRANCE, AROUND 1934–1941. The 1930s was a period of growth and expansion for the Hershey Zoo. A number of new exhibit buildings were added during this time, including individual houses for primates, carnivores, small mammals, antelopes, tropical birds, pheasants, and fish, as well as outdoor cages and enclosures. By the end of the decade the zoo covered 40 acres.

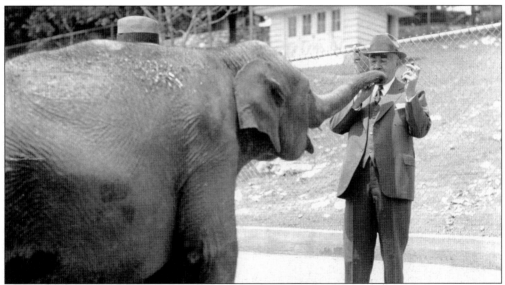

MILTON HERSHEY AT THE ZOO, C. 1938. In 1934, a pair of elephants, 3.5 years old, were added to the zoo. The elephants were only at the zoo for a few years. The zookeeper wanted to build a large, expensive building to house the elephants. Milton Hershey, who often visited the zoo, overheard a family discussion. The father said to his children, "Look, there is an elephant." The youngsters said, "We want to see the monkeys." When Hershey heard that, he said, "People are more interested in monkeys than elephants, and I won't spend the money on a building for the elephants." He said, "We'll sell the elephants," and the zoo soon did so.

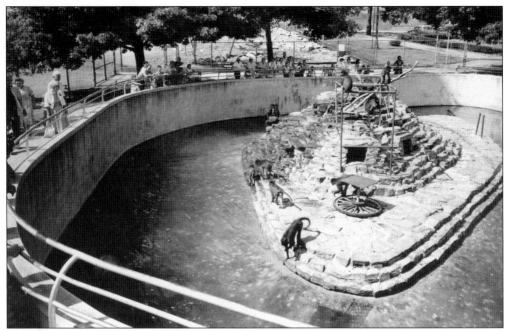

MONKEY ISLAND, C. 1954. One of the zoo's most popular attractions, Monkey Island, was added in 1954. Zookeepers stretched an aluminum plank across the moat to get to the island and care for the animals. If the keeper was not watchful, monkeys attempted to escape the island using the temporary bridge. During the winter months the monkeys were housed in the old bird house.

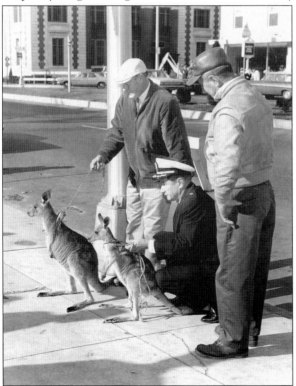

KANGAROOS FOR HERSHEY ZOO, 1967. The zoo followed the fortunes of Hershey Park during the 1950s and 1960s. There was little development, and new animal exhibits were limited to donations and trades with other zoos. In 1967, in one particularly remarkable exchange, Hershey Zoo traded two Pennsylvania raccoons for two Australian kangaroos. The exchange quickly became a press event. Seen here in this photograph are, from left to right, Raleigh Hughes, Capt. Cal Bonawitz, and Victor Blouch with kangaroos Sidney and Aussie.

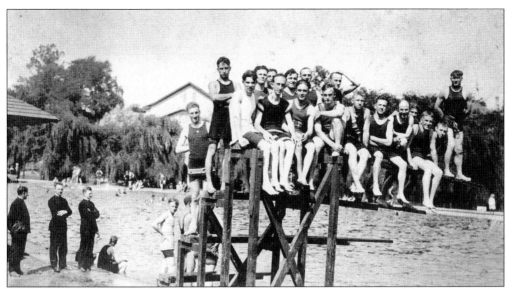

HERSHEY PARK POOL, C. 1912. Hershey Park's first pool was created by diverting water from Spring Creek to a concrete basin. The new pool measured 250 feet by 100 feet. The water was kept fresh and cold by periodically draining the pool. Diving was permitted although the deepest part of the pool was only five feet deep. (Courtesy of Neil Fasnacht.)

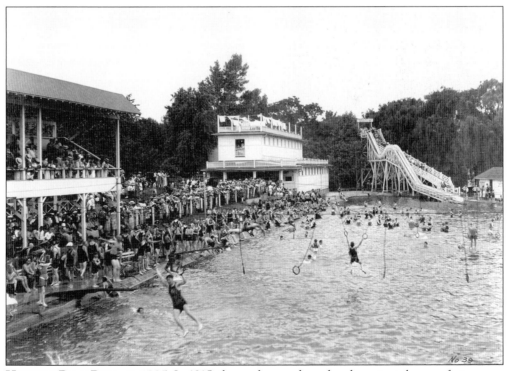

HERSHEY PARK POOL, C. 1925. In 1915, the pool was enlarged and a water toboggan feature was added to the pool complex. To ride the toboggan swimmers carried wooden "sleds" to the top of a long wooden slide and rode the sled down to splash in the pool below. The ride was so fast that riders hydroplaned for several yards before sinking into the water.

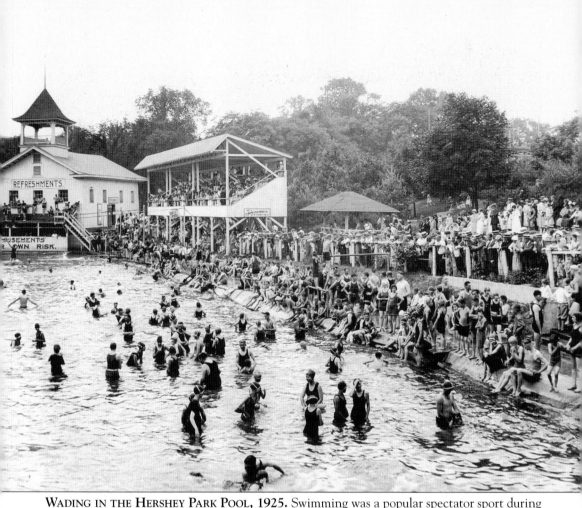

WADING IN THE HERSHEY PARK POOL, 1925. Swimming was a popular spectator sport during the early years of the 20th century. A grandstand was added to the pool to accommodate those visitors who would rather watch than swim. The pool complex included men's and women's bathhouses, where patrons could rent wool bathing suits for the day.

HERSHEY PARK POOL ENTRANCE, C. 1929. The park constructed a new pool for the 1929 season. The new pool was actually composed of four pools: a circular baby pool, a diving pool, a swimming pool, and a wading pool. A concrete island separated the swimming pool from the wading pool. Together the pools covered 35,000 square feet and contained 1.24 million gallons of filtered spring water. The admission fee for adults was 25¢ and 10¢ for children.

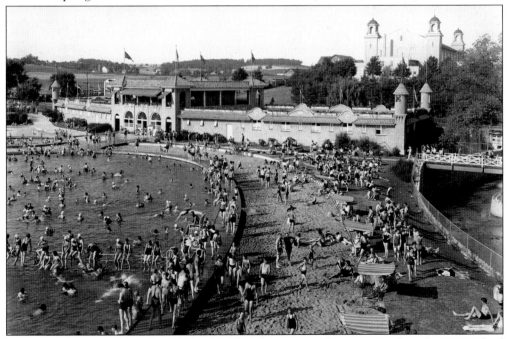

HERSHEY PARK POOL BEACH, AROUND 1929–1935. Many longtime residents have very fond memories of the park pool. Young men remember the pool as a wonderful place to bring a date if one did not have much money. The pool was located right next to the ballroom. From the pool, one could hear all the great bands that played at the ballroom, such as Jimmy Dorsey, Glenn Miller, and Harry James.

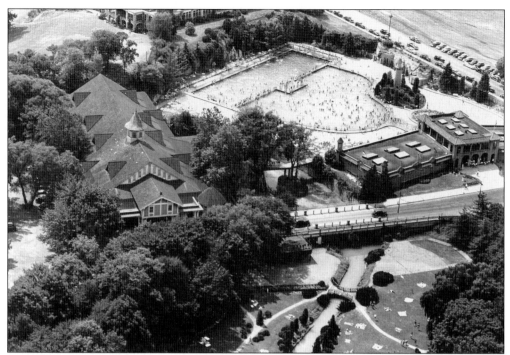

AERIAL VIEW OF THE POOL, BALLROOM, AND SUNKEN GARDEN, AROUND 1935–1940. The Hershey Park complex expanded dramatically during the 1930s with the addition of the Sunken Garden, a new swimming pool, and the park golf course. The park sought to provide a wide range of entertainment that would appeal to the entire family.

SHUTE THE SHOOTS, C. 1931. When Hershey Park built its new swimming pool complex, it did not include a water toboggan ride that had been part of the original pool. The ride's popularity prompted the park to build a separate pool for a new Shute the Shoots in 1931. The ride only lasted a few years before it was permanently closed. (Courtesy of Neil Fasnacht.)

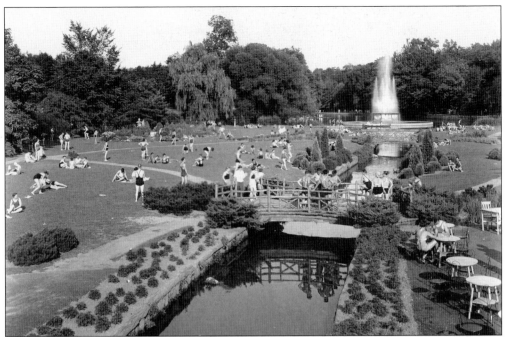

SUNKEN GARDEN, AROUND 1932–1940. The Sunken Garden was added in 1932. It was located on the east side of Park Boulevard, between the pool and the ballroom. The garden was popular with both swimmers and dancers. During the day it was used by swimmers to sunbathe. In the evening, dancers took a break from the ballroom to stroll along the garden paths.

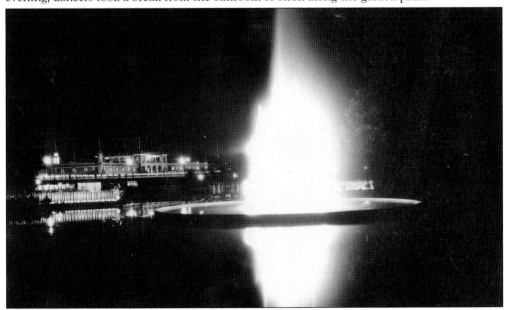

ELECTRIC FOUNTAIN AT NIGHT, AROUND 1935–1950. As a focal point for the Sunken Garden, the park purchased a spectacular electric fountain that was installed in the center of the pond. The fountain featured five small fountains with colored lights. The central nozzle shot a spray of water 65 feet in the air. The fountain light show took 30 minutes to complete the full sequence. To enhance the effect, the park also added two water curtain lights along the face of the dam.

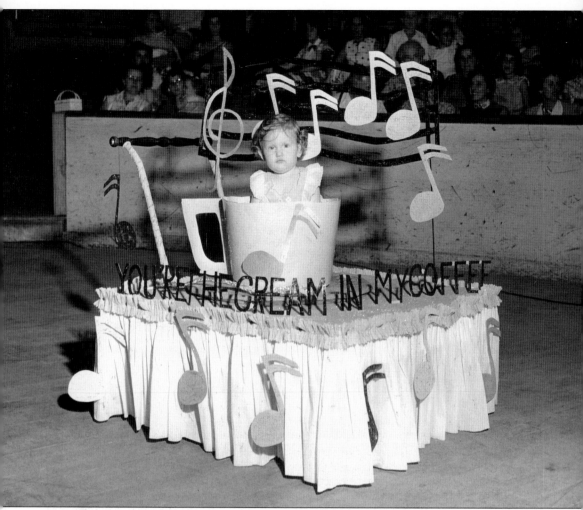

BABY PARADE, 1955. Hershey Park sponsored a baby parade each summer as part of its Kiddie Week activities beginning in 1936 until 1973. Baby parades had their start in Ocean City, New Jersey. The seaside baby parades were held on the boardwalk and served as an ingenious way for proud parents to brag about their children without offending anyone. The contest offered a variety of prizes including ones for cutest baby, fanciest baby carriage, best fancy costume, most original decorated carriage, fattest baby, and best comic costume. Beginning in 1947, the baby parade took place in the sports arena.

HERSHEY CREAMERY, AROUND 1930–1935. Also located in the park complex was the Hershey Creamery. The creamery operated a soda fountain in the front of the building. It was a popular destination for park guests and ballroom patrons. During band intermissions and following the end of the dance, patrons would come to the creamery for sodas and ice-cream refreshments.

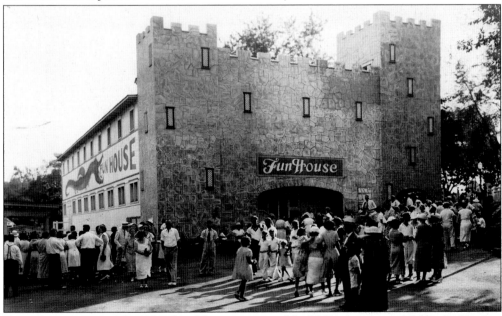

FUN HOUSE, C. 1935. In 1930, the old swimming pool bathhouse was remodeled to be Hershey Park's first fun house. Work was completed by James A. Fields of Detroit, Michigan, who had been in the fun house business for more than 20 years. It was an active fun house that had four wooden slides, a barrel roll, a spinning disk, and a ride called the cup and saucer. It also contained a walk through, rolling tunnel.

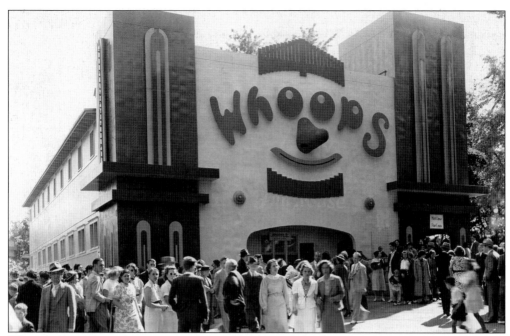

WHOOPS FUN HOUSE, AROUND 1940–1945. The park fun house was remodeled in 1938, with new stunts added, and renamed Whoops. Philadelphia Toboggan Company did the remodeling and provided the stunts.

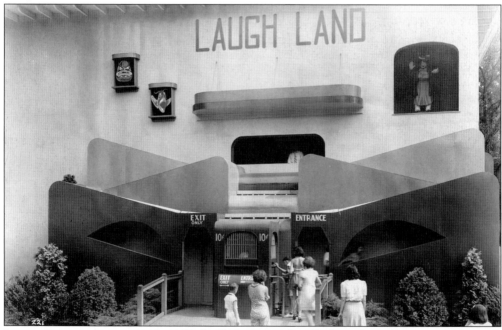

LAUGH LAND, AROUND 1945–1955. In 1938, a second, walk-through, fun house named Death Valley was added. In 1940, new stunts were added and it was renamed Laugh Land. Laffing Sal, a mechanical laughing woman that had been purchased from the Philadelphia Toboggan Company, was added and entertained passersby. She became an icon of Hershey Park, and many people who visited the park in the 1940s, 1950s, and 1960s have fond memories of her.

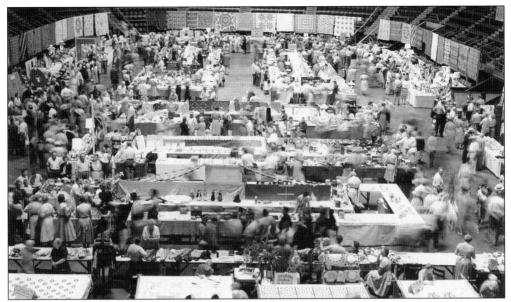

PENNSYLVANIA DUTCH DAYS, C. 1955. The first Pennsylvania Dutch Day was held on August 27, 1949. A few displays were set up in the Hershey Arena, most of them borrowed or owned by class members. The planners estimated that perhaps 2,500 people would come see the displays, which included hand-painted works from the art class, a few donated quilts, and kitchen utensils. However, 25,000 people turned out that day. The success of that one-day affair led to its expansion to three days the following year.

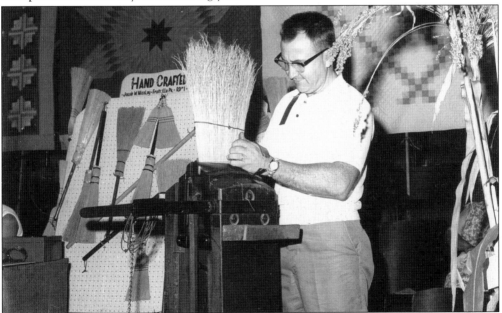

BROOM MAKER AT DUTCH DAYS, 1960. Dutch Days sought to showcase the authentic arts, crafts, and customs of the early Pennsylvania German pioneers who settled South Central Pennsylvania. The festival offered a wide range of crafts and activities that celebrated the "Dutch" way of life such as apple butter making, threshing, quilting, pottery, musical concerts, and, of course, food.

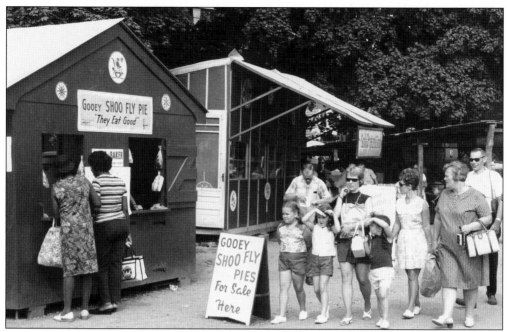

SHOO FLY PIE STAND, DUTCH DAYS, AROUND 1965–1970. Dutch Days grew into a true community-wide event with activities taking place in Hershey Park, Hershey Arena and Stadium, and the Hershey Community Building. Various community organizations got involved and held fund-raisers by offering Pennsylvania Dutch treats and dinners.

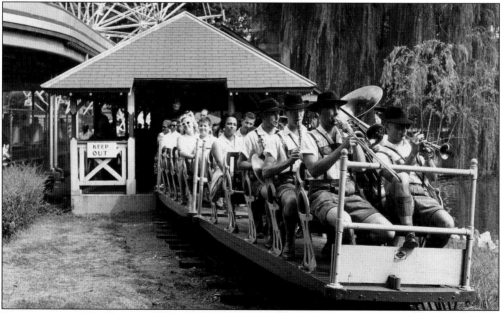

GERMAN BAND TRAVELING ON THE MINIATURE RAILROAD, AROUND 1960–1970. During Dutch Days evening concerts were held at the Hershey Bandstand and the ballroom offered square dancing with old-time fiddlers. Dutch Days was administered by a volunteer committee. In spite of the ever-expanding scope of activities, for many years no admission was charged to any of the events. Dutch Days was discontinued after 1979.

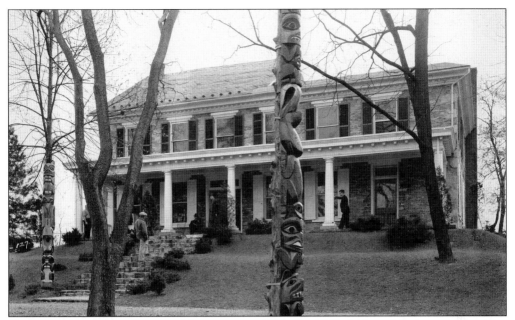

HERSHEY AMERICAN INDIAN MUSEUM, C. 1933. In 1933, Milton Hershey purchased a significant collection of Native American artifacts assembled by John G. Worth of Philadelphia. Worth, a knowledgeable collector of Native American material culture, spent many years in the American West and served as a civilian scout during the last of the Indian Wars. The museum was located on East Derry Road, adjacent to the chocolate factory.

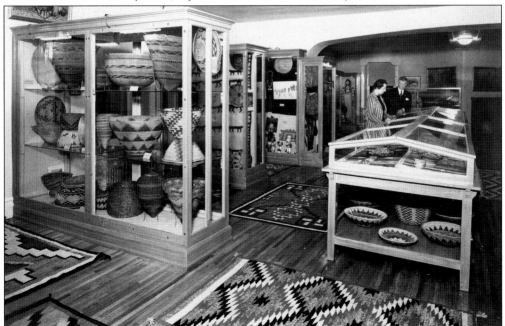

HERSHEY INDIAN MUSEUM EXHIBITS, C. 1933. Milton Hershey wanted to make his model community an enjoyable and interesting place to live. Creating a museum provided residents and visitors with the opportunity to experience places and cultures that were different than their own.

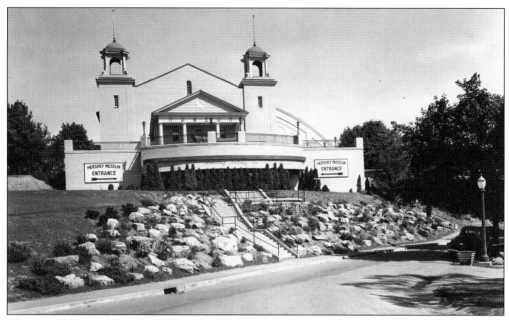

HERSHEY MUSEUM, AROUND 1945–1950. In 1935, encouraged by the success of his museum, Hershey purchased a substantial collection of Pennsylvania-German artifacts from the estate of George H. Danner of nearby Manheim, Lancaster County. In 1938, the museum moved to the Convention Hall that was remodeled to accommodate both the Pennsylvania-German and the Native American collections.

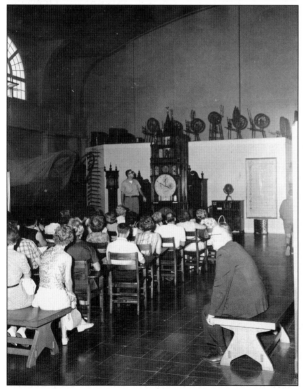

APOSTOLIC CLOCK, HERSHEY MUSEUM, C. 1970. The Apostolic Clock was one of the museum's most popular exhibits. Acquired as part of the Danner collection, the Apostolic Clock was built by John Fiester. It was completed in 1878. Fiester traveled the countryside with the clock, billing it as the ninth wonder of the world.

Four

SUCCESS THROUGH CHANGE

HERSHEYPARK

Milton Hershey's death in October 1945 had a dramatic and long-reaching impact on the community. The town had developed through his vision and leadership. Without him, there was a vacuum in vision, and his businesses responded by trying to maintain the status quo rather than grow.

Everything was changing around Hershey, particularly in travel and leisure. There was a significant increase in the amount of leisure time available to people in the post-war years. A booming economy resulted in families with the means and the time to take vacations. Cars became the preferred means of travel for family vacations. Television had a dramatic impact on people's expectations for what they should experience when they went on vacation. The development of Disneyland in 1955 forever changed how people viewed amusement parks and what they anticipated experiencing at a park. Millions of people were exposed to Disneyland through an ABC network television series, *Disneyland*, which showcased the new amusement park. Disneyland reflected the energy and expectations of post-war America. Americans were responding to experiences that were new and modern. They wanted to break away from their memories of the decades of depression and war. Disneyland captured the United States' imagination and reinforced the post-war convictions that the past was tired and the future was bright.

Traditional amusement parks would not fare well in such a climate. They were perceived as belonging to the past and were viewed as tired and a bit boring. Hershey Park, in the wake of Milton Hershey's death, was not able to make a dramatic change. Hershey Zoo reopened in 1950, but followed the traditions and exhibits established before the war.

The park did make some efforts to respond to changing times. In 1959, a rock-and-roll band, Bill Haley and the Comets, performed at Hershey Park Bandstand. Dry Gulch Railroad, the park's first major ride in more than a decade, was added in 1961. The park continued to make some efforts toward improvements in the 1960s. New rides were added, including the Aero Jet and the Sky Ride. The Mill Chute was redesigned and rethemed to become the Lost River. To address the community's increasing problems with traffic, Hershey Estates and Hershey Chocolate Corporation financed the construction of the monorail to ease downtown congestion. But these kinds of changes were like putting a finger in the dike. Public interest had been captured by Disney's imagination. Television had opened a window to a variety of new experiences and worlds.

By the late 1960s, the park was looking a bit worn around the edges. The park also struggled with increasing vandalism and petty theft because the open park layout was a boon to those bent on mischief and there was no effective way to control access with the parks' multiple entrances. The park in its current form was not a viable proposition.

By 1970 Hershey Estates had decided that in order to save the park, drastic changes would have to be made. In 1971, the park changed its name to Hersheypark, fenced in the park, and

established a one-price admission plan of $3.50 for adults. Needless to say, these changes were not welcomed by all. The community protested loudly. The next two decades would be full of highs and lows for the park.

The park's redevelopment was designed to be implemented in phases. The first phase, completed for the 1972 season, included Carrousel Circle and the Craft Barn area, originally known as Der Deitsch Platz (the Pennsylvania Dutch Place), Aqua Theater, and the Animal Garden petting zoo. The second phase, completed for the 1973 season, included the construction of Tudor Square and Rhineland. The Giant Wheel was added to Carrousel Circle in 1973.

From the beginning, the redeveloped Hersheypark faced a variety of challenges. In June 1972, Hurricane Agnes hit, flooding Hershey and the park. These setbacks, as well as continuing cost overruns with construction, took a toll on development plans.

Doubts and concerns about this new vision for Hersheypark were erased with the opening of the 1973 season. Opening day was a huge success and heralded a highly successful season.

The energy crisis of 1973–1974 also forced the park to modify plans. Planned outdoor air conditioning for ride queues was eliminated. Plans to construct a new themed contemporary area and a revolving tower were delayed. In spite of these setbacks, development continued with the addition of a new amphitheater, the Trailblazer, and the Sky Ride. In 1977, the sooperdooperLooper, the first looping roller coaster on the East Coast, opened.

The last major addition to Hersheypark for many years was the redevelopment of the old Hershey Zoo as ZooAmerica, a themed zoological park. By building a bridge across Park Boulevard, Hersheypark was able to directly link the zoo to the park. On March 9, 1982, ZooAmerica became one of only 50 zoos in the United States and only two in Pennsylvania, Philadelphia, and Hershey, to be recognized for its professionalism and receive accreditation by the American Zoo and Aquarium Association.

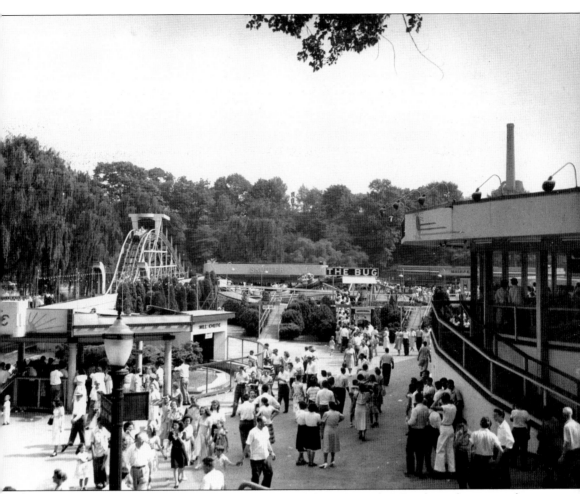

COMET HOLLOW, AROUND 1946–1950. For most of the 1950s and 1960s, the park continued its tradition of adding new rides and attractions. However, the rides added to the park during this time were carnival-style rides, such as the twin Ferris wheels, a miniature golf course, and several new kiddie rides. Hershey Park remained a popular destination in the post–World War II years. The park benefited from the full scope of attractions Hershey offered, including golf, swimming, dancing, movies, and tours of the Hershey Chocolate Factory.

CUDDLE UP, 1947. Philadelphia Toboggan Company was an important partner with Hershey Park. In 1947, one year after the Comet was completed, Philadelphia Toboggan Company sold Hershey a large five-wheel model Cuddle Up with 12 cups each holding four passengers. The cups spun around intersecting concentric circles or wheels. The Cuddle Up was a popular ride in the park into the 1980s.

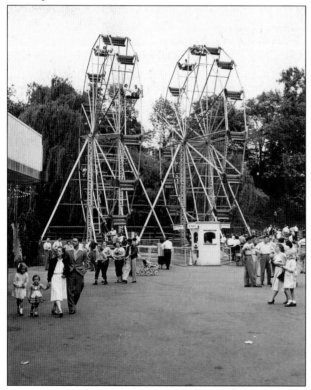

TWIN FERRIS WHEELS, AROUND 1955–1960. In 1950, Hershey Park purchased two Ferris wheels from Eli Bridge of Jacksonville, Illinois. The ride featured 66-foot-high wheels that held 32 adults in each of the 16 cars. While a popular ride, the midway style Ferris wheels reflected the park's limited resources to add major new attractions in the post-war years.

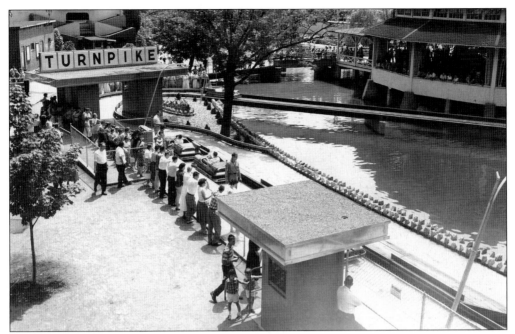

TURNPIKE RIDE, AROUND 1960–1965. A new turnpike ride was added to the park in 1960. Its gasoline-powered cars drove along a one-half mile track that crossed Spring Creek twice. Following Disney's lead, the park added theme elements to the ride, including a toll gate entrance and a tunnel. The turnpike was designed and built by employees of the Hershey Lumber Company.

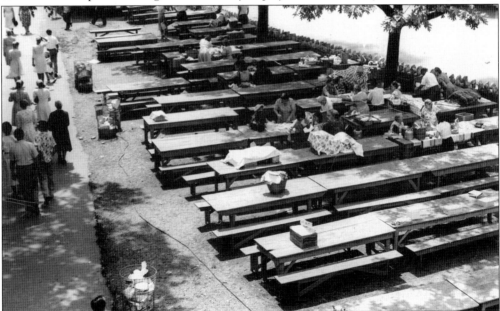

PICNIC GROUNDS, AROUND 1950–1960. Hershey Park continued to add picnic areas up until 1967. The park provided tables, benches, and pavilions to seat 6,000 people. For many years the park provided free wood and stoves to picnickers. In addition to the picnic areas, the park offered catered meals to groups in covered pavilions. Refreshment stands were scattered through the park, offering ice cream, soda, popcorn, french fries, and, of course, Hershey's chocolate.

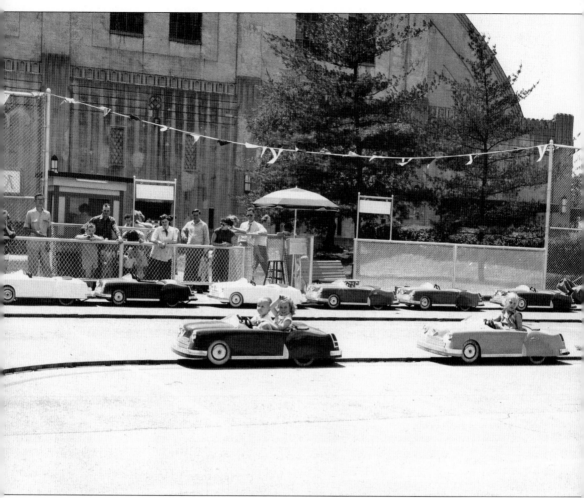

KIDDIE TURNPIKE, C. 1960. Hershey Park's emphasis on appealing to all ages made the park attractive to families. The Kiddie Cadillac ride was popular with young children. The cars followed a track, preventing damage to the cars and drivers. The cars were designed to look just like the cars the children's parents drove. Hershey Park's full-size turnpike ride required continual maintenance as cars repeatedly crashed into railings along the ride course.

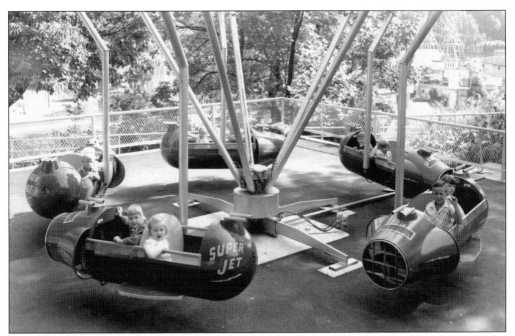

SUPER JET RIDE, C. 1965. The baby boomer generation sparked the growth of Kiddieland. Rides such as the Super Jet ride appealed to growing numbers of young families visiting Hershey Park. Over the years many kiddie rides have been given new life by retheming. Super Jet can still be found in the park, now known as the Busy Bees ride.

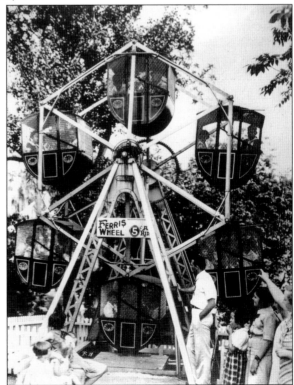

KIDDIE FERRIS WHEEL, AROUND 1935–1945. The Ferris wheel was one of the park's first kiddie rides. The ride's small scale made it more appealing to children. It was not uncommon for ride operators to stop the ride and permit children with a change of heart to exit the ride early.

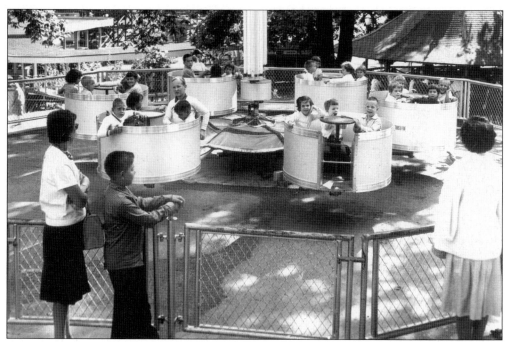

TUBS OF FUN, C. 1961. Hershey Park expanded Kiddieland in 1961 with two more rides. In addition to Tubs of Fun, a jet airplane ride was also added. With these new rides, Kiddieland offered nine rides costing a nickel each.

MONORAIL, 1969. Hershey Foods Corporation partnered with Hershey Estates to construct the monorail. Hershey Foods Corporation sought relief from downtown congestion from the thousands of people coming to tour the chocolate factory each day. Hershey Park benefited with a new ride that provided great views of the park and zoo.

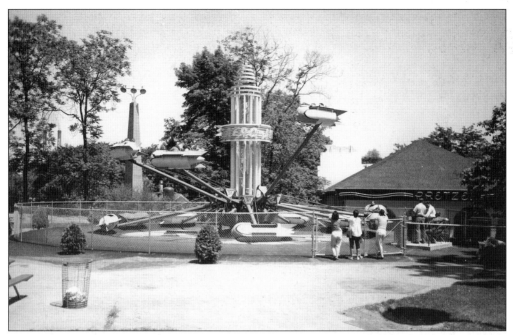

AERO JET, C. 1965. Hershey Park replaced the Aerial Joy Ride with the Aero Jet in 1962. It was the first park ride to use a hydraulic system to lift the cars. As the ride spun around, passengers could control the up and down movement of their jet cars. The ride was located close to Kiddieland.

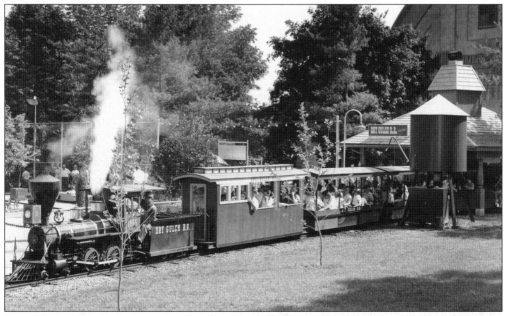

DRY GULCH RAILROAD, C. 1961. Hershey Park added a steam-powered train that ran from near the arena to Park Avenue in 1961. The ride cost 25¢. One unique feature is its 235-foot trestle bridge, which crosses a 40-foot-deep gorge. The trestle is a perfectly scaled down version of a Baltimore and Ohio Railroad bridge. In the 1980s, as Hersheypark expanded, the railroad tracks were rerouted to form an oval track and a second train and a tunnel were added.

SHOOTING WATERS ARCADE GAME, 1967. Hershey Park included a wide array of arcade games and penny attractions. One of the first arcade attractions was Mo-Skeet-O, a skeet-shooting game that was installed in 1941. In addition, the park featured a penny arcade with lanterns shows, pinball, games, and penny machines that dispensed celebrity collector cards.

ROUND UP, C. 1970. In 1968, a Round Up ride was purchased from Frank Hrubetz and Company. Operating on the principal of centrifugal force, the ride spun faster and faster until the speed raised the circular cage to a 30-degree angle. Centrifugal force held the riders in place. In later years the ride was renamed the Rotor.

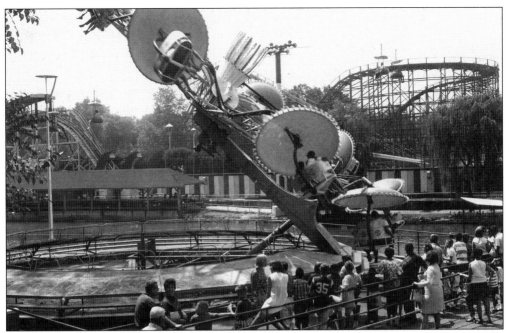

PARATROOPER, C. 1975. This ride was purchased in 1967 from Frank Hrubetz. Riders hung under individual canopies in two seat cars. As the ride spun around it would slowly lift to a height of 42 feet. It was originally located on the south side of Spring Creek near the old amphitheater. After the park was remodeled, the ride was relocated to Comet Hollow.

SOUVENIR BUILDING, C. 1950. As funding declined, Hershey Park was forced to cut costs to remain profitable. Noncritical maintenance was often deferred. The emphasis on being a clean and tidy park faded, and a full cleaning was limited to once a week when the park was closed on Mondays. As a result, trash often was visible.

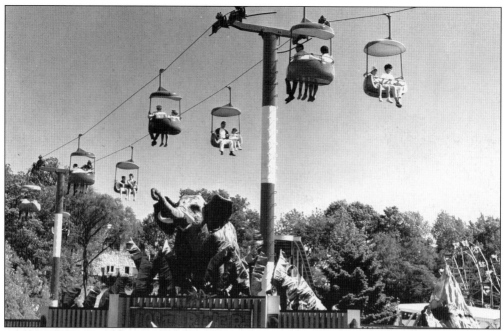

LOST RIVER AND SKYVIEW RIDES, C. 1966. For the 1963 season, the park rethemed the Old Mill Chute to make it more exciting. The ride was given a tropical setting, and a mechanical elephant was placed on top of the ride entrance. A few years later the park added the Skyview Ride, a ski lift ride that started at the top of Comet Hollow and carried riders across Spring Creek and back.

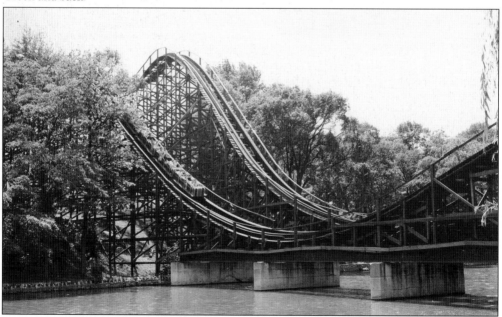

THE COMET, AROUND 1960–1970. Hershey Park's roller coaster remained the park's premiere attraction in the post-war years. Even its thrilling ride could not overcome the park's declining appearance or increasing acts of vandalism and petty theft that plagued the park in the 1960s. By the end of the decade, the park needed a significant change if it was to survive and prosper.

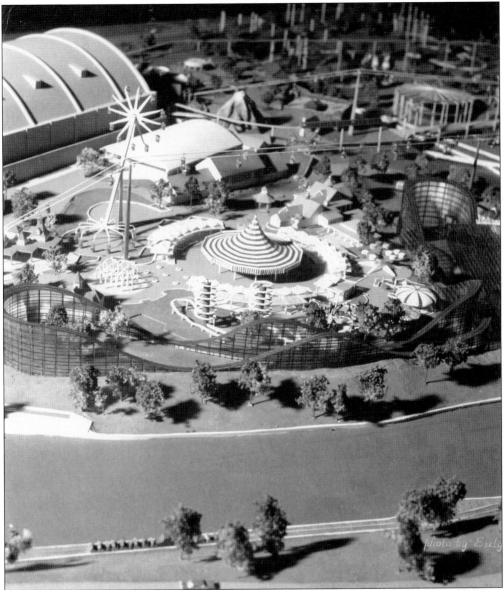

MODEL FOR HERSHEYPARK, 1970. John O. Hershey, then Hershey Estates vice president, was asked by chairman Arthur Whiteman to take a look at the park and see what might be done. He visited parks across the United States and met with Randal Duell and Associates, the firm that was hired to develop plans for a themed Hersheypark. Randal Duell was responsible for the design of most of the United States theme parks created in the 1960s, 1970s, and 1980s. This tabletop model shows the plan for Carrousel Circle and Der Deitsch Platz Plaza. The arena is visible in the background.

DER DEITSCH PLATZ UNDER CONSTRUCTION AND COMPLETED, 1972. The new park was designed to be constructed in phases. The first phase included the Craft Barn area and Carrousel Circle. Weather during the spring of 1972 was unusually wet, and construction was delayed. Extra workers had to be hired to finish the area in time for the park's May opening. The Craft Barn was inspired by Dutch Days. The park brought in craftspeople to demonstrate and sell their wares. Among the crafts represented were quilting, blacksmithing, ceramics, leatherworking, stained-glass work, broom making, and doll making.

STROLLING PERFORMERS, C. 1990. In addition to gating the park and introducing a single-price admission for the 1971 season, the new park added a number of strolling performers to the musicians and actors that continued to appear at the bandstand. There were no additional rides or attractions added to the park that year.

FURRY TALES, 1971. Hersheypark had the Furry Tales created after Hershey Foods Corporation resisted the idea of creating product characters for the redesigned park. Violet the Skunk, Chip the Chipmunk, and Dutch the Bear fulfilled the role of park mascots, each day singing and dancing throughout the park and appearing for photograph opportunities.

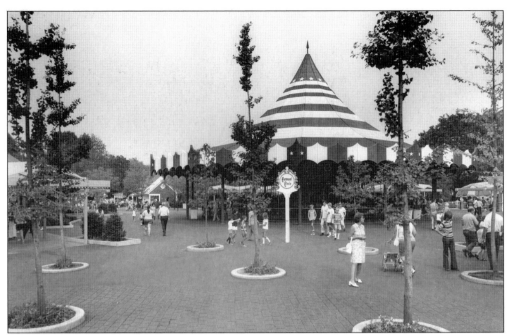

CARROUSEL CIRCLE, 1972. Hersheypark moved its carrousel from its old location by Spring Creek to be the centerpiece of the park entrance during the winter of 1971–1972. The move was timely since the ride would have been severely damaged by flooding caused by Hurricane Agnes in June 1972. The area was officially dedicated on May 7, 1972.

BARBI BENTON AND THE FURRY TALES, 1976. Hersheypark offered a wide variety of entertainment while trying to appeal to a broad range of park guests. Barbi Benton appeared at the amphitheater during the week of July 19-24, 1976. In 1976, she was best known as a country music singer appearing regularly on the television show *Hee-Haw*.

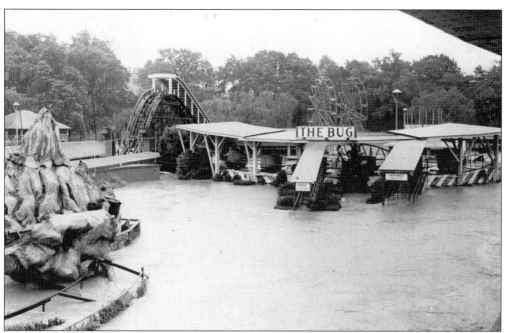

HURRICANE AGNES FLOODING, JUNE 1972. Hersheypark was forced to close for nine days following the flooding and damage caused by Hurricane Agnes. Some rides were damaged beyond repair including Lost River and Giant Slide. The revenue lost from being closed stressed the park budget and raised questions about the future success of the theme park.

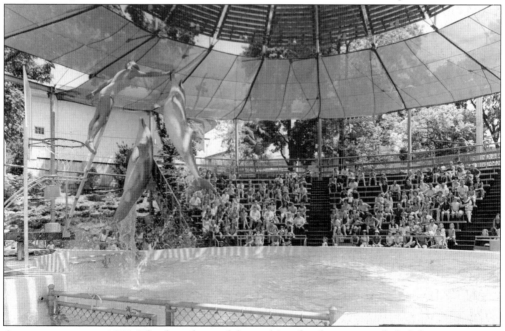

AQUATHEATER, C. 1972. The first phase of the park's redevelopment included the construction of an aquatheater. The water attraction featured shows with dolphins and sea lions. The animals spent their summers at Hersheypark and were transported to the southern United States for the winter months.

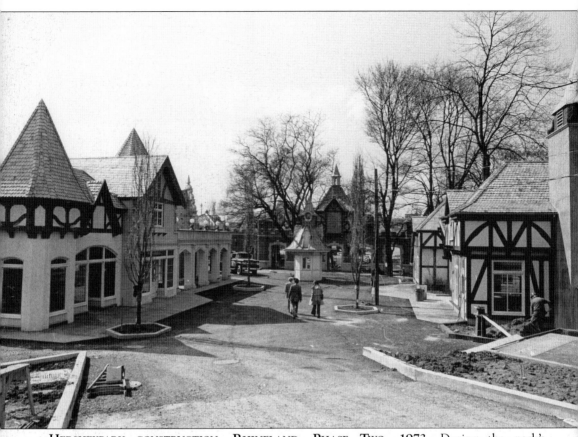

HERSHEYPARK CONSTRUCTION, RHINELAND, PHASE TWO, 1973. During the park's redevelopment, construction was plagued by bad weather and resulting cost overruns. Rhineland and Tudor Square were the major areas developed for the 1973 season. Tudor Square was developed as the new entrance for Hersheypark. Rhineland connected the new entrance with the recently completed Carrousel Circle.

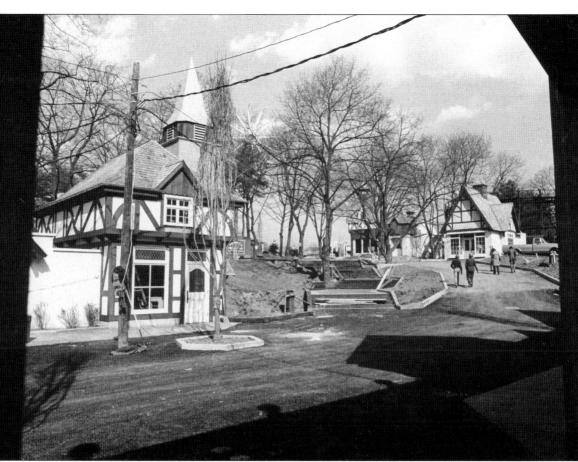

HERSHEYPARK CONSTRUCTION, RHINELAND, 1973. Like everything else built during the transition years, Tudor Square and Rhineland were built to last, with complete four-sided buildings instead of false fronts that most amusement parks constructed for their buildings. In all construction, significant effort was made to save many of the existing trees, and new trees were added to landscaping throughout the park. There were several rides planned for Rhineland, though only one, Sky Ride, was ever built.

OPENING DAY, 1973. John O. Hershey, Hershey Estates vice president, served as master of ceremonies for Hersheypark's Opening Day. All doubts about the wisdom of redeveloping the park were erased by the end of that season. The park experienced record attendance with over one million visitors and record profits that year.

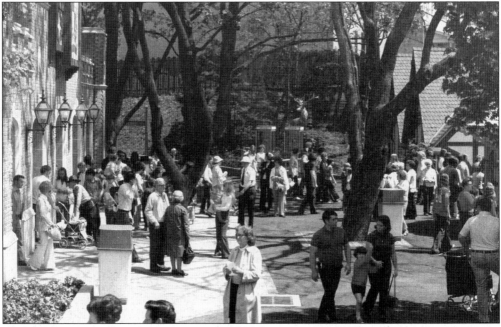

TUDOR SQUARE ENTRANCE, 1973. With the construction of Tudor Square, Hersheypark moved its main entrance from the monorail station located next to the arena to a spot closer to the newly opened Hershey's Chocolate World. With its many shops, Tudor Square was envisioned as an area of the park that could be open all year round.

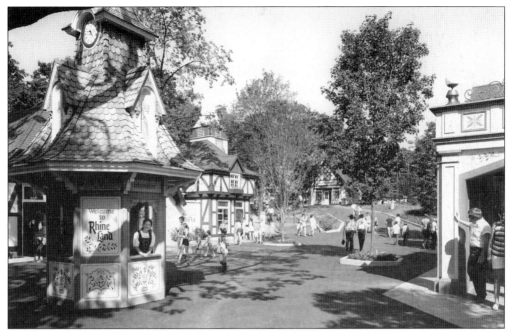

RHINELAND, 1973. This was a German-themed area that began at the Tudor Castle admission gate. The buildings had steeply pitched wood shingle roofs. At first employees were dressed in bright period costumes to emphasize the German atmosphere. The costumes were not practical and were soon replaced by simpler, more practical park uniforms.

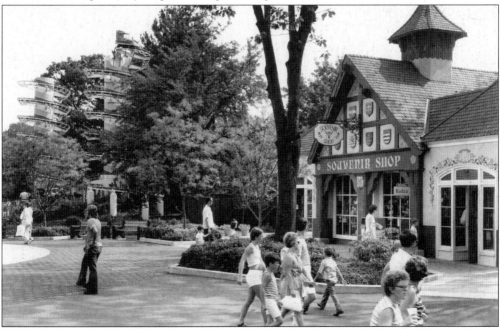

UPPER RHINELAND, 1973. Visitors walked through Rhineland to Carrousel Circle. Here a number of rides encircled the carrousel, including the Twin Toboggan ride, the Monster, and the Scrambler. The Twin Toboggan was popular, but the two passenger cars often got stuck in the central vertical shaft and the ride was removed after a few seasons.

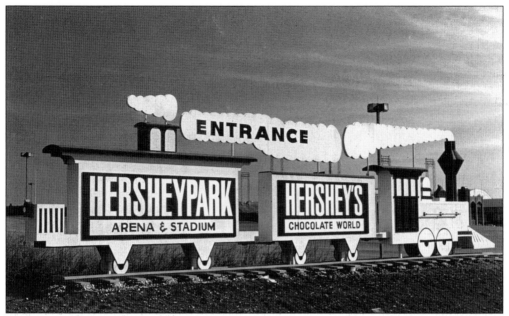

ENTRANCE SIGN, 1973. Hershey's Chocolate World opened in 1973, providing Hershey visitors with a year-round attraction. By locating Chocolate World near the new park entrance, visitors could park once and have access to some of the town's most popular attractions. This train was a familiar landmark for Hersheypark and Chocolate World until 2002, when parking was reconfigured to accommodate the new Giant Center.

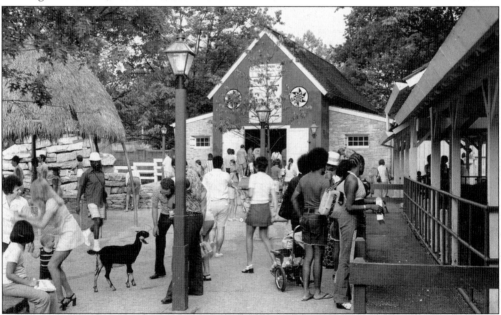

ANIMAL GARDEN, 1972. A petting zoo replaced the old Hershey Zoo that had closed in 1971. The Animal Garden featured a new Monkey Island, a barnyard petting zoo, and baby animals such as llamas and elephants. The attraction was designed without much input from experienced zookeepers. Its Monkey Island was not properly designed, and when monkeys were placed on the island, they quickly escaped. The Monkey Island was quickly repurposed as a geese pond.

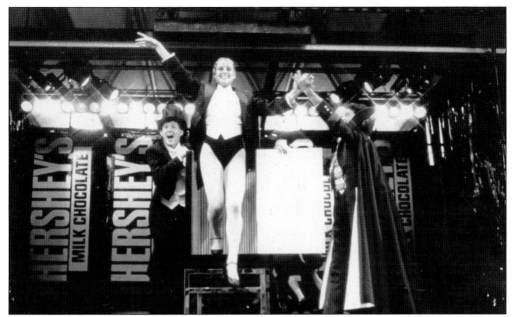

MAGIC SHOW, C. 1990. Hersheypark has a long tradition of offering magic shows as part of its entertainment line-up. In 1973, Hersheypark contracted with Mark Wilson, a nationally recognized magician, to provide entertainment. At first his shows were held on an open-air stage near the arena. The Music Box Theatre was soon constructed on that site, and Mark Wilson's Hersheypark Magical Spectacular became one of the park's most popular acts.

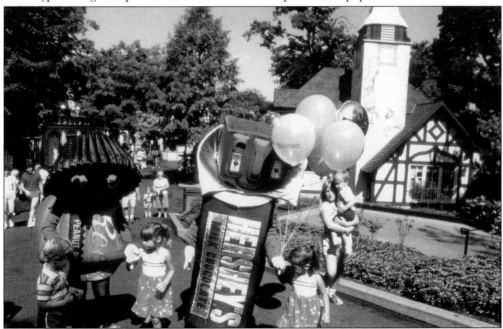

HERSHEY PRODUCT CHARACTERS, 1975. Despite some initial reluctance, Hersheypark was able to convince Hershey Foods Corporation that product characters would enhance both companies, and in 1973, the park began using strolling bar characters such as the Hershey Bar, Reese's Peanut Butter Cups, Krackel Bar, and the Hershey Kiss as park mascots.

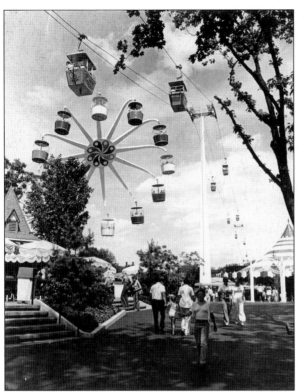

GIANT WHEEL AND SKY RIDE, 1973. Two new rides were added to the park for the 1973 season. Sky Ride was a cable-car ride that traveled from Rhineland across the park to the Coal Cracker area. It was both a ride and a means of transportation for park guests. Giant Wheel was the park's first major European ride. It featured two wheels attached to a 116-foot crossbar. Each wheel had 12 cabins that held eight people. The ride rose to 130 feet above the ground, providing a great view of the entire park.

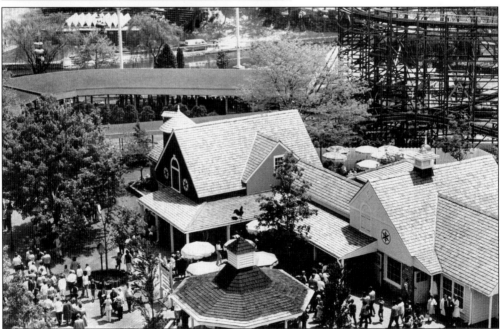

VIEW FROM GIANT WHEEL, C. 1973. During the early years of the transition to modern theme park, Hersheypark was a blend of the old and the new. The new Der Deitschplatz Plaza gave way to the 1946 Comet Roller Coaster. The old arcade building overlooks the new amphitheater in the background of the photograph. Also visible is the loading station for the Coal Cracker.

THE GREEN TEAM, C. 1974. The United States faced an energy crisis beginning in 1973. For the 1974 season, Hersheypark implemented a number of strategies to save energy. One of the first things to go was outdoor air-conditioning on ride queues such as the Coal Cracker. The Green Team communicated the value of energy conservation in a fun and entertaining way. (Courtesy of Hersheypark.)

TRAILBLAZER, C. 1974. Hersheypark added its first new roller coaster since the Comet when it purchased the Trailblazer, a modern, high-speed coaster, for the 1974 season. The coaster features a series of tight curves that turn riders completely sideways. The Trailblazer marked the start of a new themed area for the park called the Pioneer Frontier.

TRAILBLAZER THEATRE, C. 1976. As Hersheypark developed, it created a number of new venues for entertainment. Many of the themed areas offered special music and entertainment. Limited funding meant that attractions evolved over time. At first the country-and-western band booked for the new frontier area developing around the new Trailblazer ride played on an open stage. This enclosed building was built the following year.

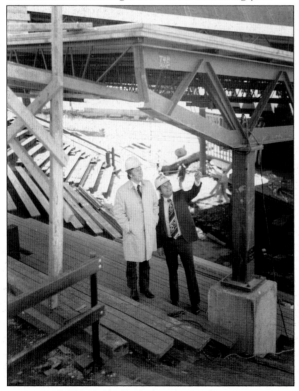

AMPHITHEATRE ROOF CONSTRUCTION, 1975. A roof was added to the amphitheater to improve visitor comfort. The roof created shade, kept guests dry in inclement weather, and made watching a performance a more enjoyable experience. Here Vice Pres. J. Bruce McKinney (left) and general manager Paul Serff survey construction progress.

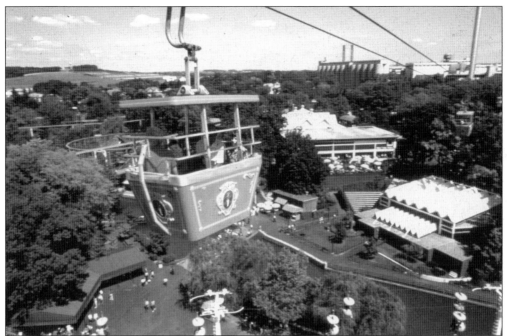

SKY RIDE, C. 1976. Sky Ride offered some of the best views of the developing park. Visitors liked to use the ride as a quick and easy way to reach the far side of Hersheypark. The ride was removed in 1992 after the park was no longer able to secure replacement parts.

TWIN TURNPIKE RIDE, C. 1975. The other ride featured in the Kissing Tower Plaza was a new turnpike ride. It featured gasoline-powered cars along a double track. Like the park's older turnpike rides, this one featured drive-it-yourself cars, but a central track prevented the cars from crashing into the railings. Park guests could choose between driving a four-seater antique car or a two-seater sports car.

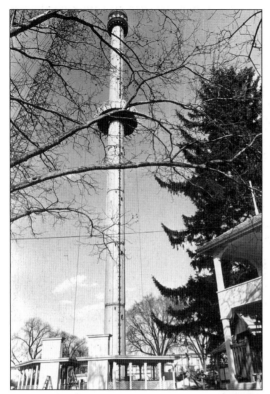

KISSING TOWER, 1975. For the 1975 season, Hersheypark planned to open a new themed area, Kissing Tower Plaza. The main attraction would be a custom tower that raised its riders 250 feet up. Built on the highest point in the park, the Kissing Tower was clearly visible throughout Hersheypark and the town. The ride was designed and manufactured by Vitamin AG, the same company that had provided the park with the Giant Wheel and Sky Ride. One of the ride's more distinctive features was its windows in the shape of Hershey's Kisses.

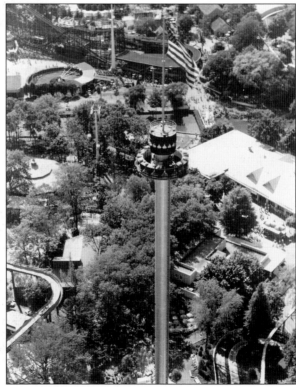

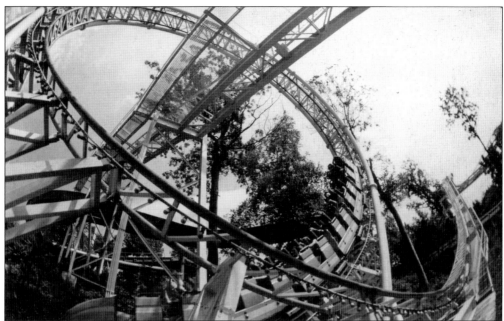

SOOPERDOOPERLOOPER, 1977.
The sooperdooperLooper marked
Hersheypark's entry into the
category of nationally recognized
theme parks. This coaster was the
first looping coaster on the East
Coast and only the second in the
United States. The new coaster
was the park's most expensive
ride to date, costing more than $3
million. The investment would
be well rewarded. In spite of some
initial start-up problems, the ride
fulfilled the park's expectations.
The summer of 1977 would stand
as the park's most successful
season for decades to come.

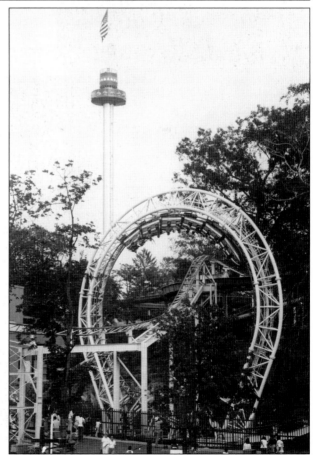

ZOOAMERICA DEDICATION, 1978. ZooAmerica was inspired by the Toronto Zoo, which was among the first zoos to display animals in naturalized environments and grouped according to their geographic region. J. Bruce McKinney, HERCO vice president, is seen standing at the microphone. CEO Ned Book is holding a clipboard.

GIRL SCOUTS AT ZOOAMERICA, C. 1978. The educational focus of ZooAmerica was an important asset for Hersheypark. The zoo provided the park with opportunities to tap into school groups and field trips. These marketing efforts were often coordinated with Chocolate World and Hershey Museum to create a daylong experience for students. Often a visit to Hersheypark could be included as a celebration or fun activity after the educational activities were completed. Zoo employee Dale Snyder shows an animal horn to scouts. (Courtesy Hershey Entertainment and Resorts Company.)

Five

HERSHEYPARK TODAY
STAYING TRUE TO
MILTON HERSHEY'S LEGACY

Entertainment continued to be a major part of the park's new program. Even though the original bandstand was razed in 1972, a new amphitheater provided a venue for headliner entertainment. Hersheypark built on its commitment to provide a variety of entertainment when it began an enduring partnership with Al Alberts, who would write all of the park's in-house dance shows. A new performance space, the Music Box Theatre, provided a venue for many of those shows. Park entertainment also included a variety of strolling musicians and performers throughout the park.

To showcase many of the major headliners performing at the park and arena, Hersheypark developed the Starlight Arcade in Carrousel Circle. While the redeveloped Hersheypark was clearly a success, senior management changes in the park's parent company, Hershey Estates, would have a significant impact on continuing investment in the park. Ned Book, a hotelier, became chief executive officer of Hershey Estates in 1974. His vision for the company emphasized developing Hershey's lodging and also expanding the company's investment in ventures located outside of Hershey. Over the next 10 years, Hershey Estates (renamed HERCO, Inc., in 1976) aggressively invested in a variety of ventures outside of the local community. This vision of expansion was reinforced following a disastrous year in 1979. That year there was a nuclear accident at nearby Three Mile Island and a polio scare in Lancaster County, Pennsylvania, which discouraged tour buses from traveling through Lancaster. These two events resulted in the park's worst season since it had reopened as a themed amusement park.

HERCO's rapid and aggressive expansion, coupled with unfortunately timed events, resulted in a financially strapped company. It would not be until the early 1990s that HERCO was able to turn itself around financially and refocus its energy and resources toward its Hershey properties.

Without capital infusion to add major new rides and attractions, Hersheypark explored other ways to increase revenue. Expanding the park season was an obvious solution. Candylane was first launched in 1983 after many years of discussion. Christmas Candylane featured unique shops, including 30 independent vendors offering handmade crafts. There were a puppet theater, Santa, live reindeer, and performing area choirs for entertainment. Thematically, Candylane evoked the spirit of the board game Candy Land, with different areas named for places such as Ribbon Candy Rapids, Sugar Sprinkle Swamp, Lemonade Lake, and Taffy Tunnel. Decorations reflected the Candy Land motif. The lighted tree at the top of the Kissing Tower was introduced that year. Candylane was developed in partnership with Hershey's Chocolate World, Hershey Museum, ZooAmerica, and Reading China and Glass. Candylane was decorated with 25,000 Christmas lights that first year. The next year, Candylane expanded further into the park, adding more rides and entertainment. Over the years, expansion continued as larger areas of the park and a variety of entertainment were included. Holiday lighting continued to be an important part of the event with eventually more than 400,000 lights decorating Hersheypark for the holiday season.

In a similar fashion, the park built on ZooAmerica's success with Creatures of the Night, first offered by the zoo in 1981 as a single-night event. In later years, the event was expanded

to the weekend closest to Halloween. Zoo educators offered bat and snake demonstrations, and a storyteller told ghost stories by a campfire. By 1995, the event had expanded to three weekends. Its success prompted the park to join in and open select rides that year. With the park's participation, the event was renamed Hersheypark in the Dark.

Beginning in 2000, Springtime in the Park was developed to extend the park's season. Opening for one weekend in mid-April, the park features select rides as a preview of the coming season. Recalling the park's tradition of baby parades, Springtime in the Park features a stroller parade with prizes for the best decorated stroller.

During the 1990s, new areas were developed and several new rides were added. Minetown was expanded with a new arcade and new rides such as the Flying Falcon. The Pioneer Frontier added the Sidewinder in 1991. Hersheypark expanded the boundaries of the park with the development of Midway America. The new area significantly expanded park acreage, easing a sense of congestion present on the park's busiest days. In spite of the additional room to grow, in 1998 Hersheypark's next ride, Great Bear, was a demonstration of the park's ability to add major new rides within the footprint of the original park.

Hersheypark's success and its status as one of the United States' leading theme parks was recognized in 2000 when the park received the Applause Award at the International Association of Amusement Parks and Attractions Convention in Atlanta, Georgia. The Applause Award is a highly coveted international honor.

The year 2007 marks the 100th anniversary for Hersheypark. The park will celebrate this landmark with the opening of a new water park, the Boardwalk at Hersheypark. In addition to special centennial events held throughout the summer, the park will incorporate signage in the park celebrating its rich history. Hershey Museum will open a new exhibit that explores Hersheypark's 100 Years of Happy.

The story of Hersheypark's growth and development is remarkable as a story of enduring success through changing times and attitudes. It is also remarkable for its commitment to reflecting Milton Hershey's vision for the park: to be a clean, green destination that offers quality entertainment to families and guests of all ages.

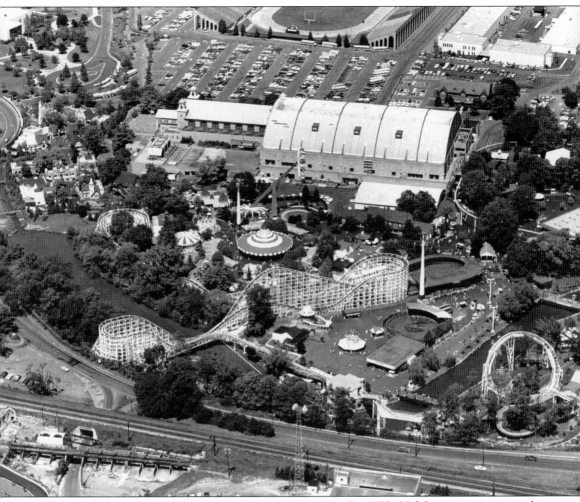

AERIAL VIEW OF HERSHEYPARK, AROUND 1977–1981. In 1975, *Holiday* magazine named Hersheypark the cleanest and greenest amusement park in the United States. In its redevelopment as a themed amusement park, Hershey had taken great care to save as many mature trees as possible and planted many additional new trees. In addition, the park was enhanced by extensive flower beds and plantings throughout the park grounds. After the success of sooperdooperLooper, Hersheypark would not add any major new rides until 1987. To maintain attendance, Hersheypark promoted itself as a clean and green, family destination. Over the next 10 years, a few smaller rides were added and others were moved around every few years to increase interest.

COMET HOLLOW, AROUND 1990–1995. Comet Hollow has seen a changing mix of rides and amusements over its long history. Hersheypark strives to provide a mix of rides and attractions designed to appeal to everyone, from major thrill rides to fun kiddie rides, and arcade games and souvenir shops for those who prefer their entertainment with both feet on the ground.

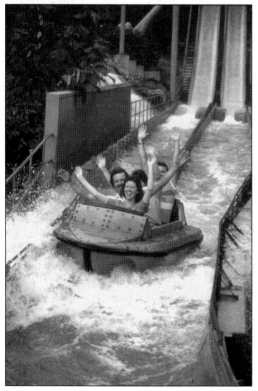

COAL CRACKER, C. 1975. After the Mill Chute was damaged by flooding caused by Hurricane Agnes, the park wanted a new water flume. The Coal Cracker was added in 1973. The ride was themed as an old Pennsylvania mining town. It was a new kind of flume ride and featured two 45-foot chutes and a bump at the bottom of the chute that pushed the boats into the air for a second splash-down. (Courtesy of Hersheypark.)

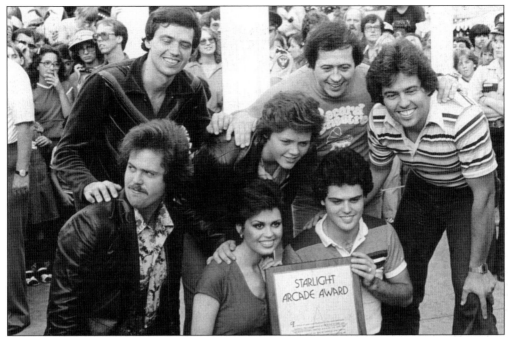

OSMOND FAMILY RECEIVES THE FIRST STARLIGHT ARCADE AWARD, 1979. Many headline entertainers came to Hersheypark, Hershey Stadium, and Hersheypark Arena to perform. Beginning in 1979, Hersheypark began a tradition of capturing their handprints in cement to honor their appearance at a Hershey venue. The cement slabs were placed in the Starlight Arcade adjacent to Carrousel Circle.

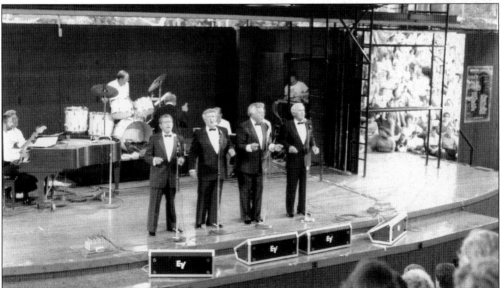

AL ALBERTS AND THE FOUR ACES, 1983. In 1971, Hersheypark began a satisfying partnership with Al Alberts to develop all the park's in-house entertainment shows. Today the partnership continues with Alberts company, Allan Alberts Production Company. Alberts was the founder of the Four Aces, a popular 1950s singing group. From 1961 to 2001, Alberts hosted "Al Alberts Showcase" on Philadelphia Channel 6-WPVI.

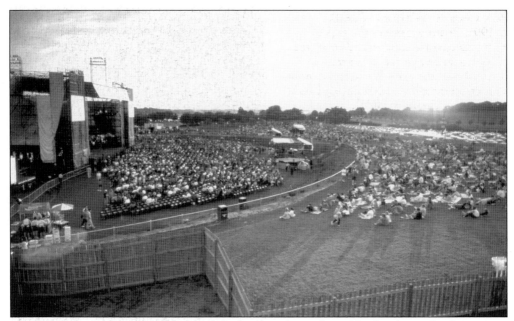

STAR PAVILION, C. 1996. As a way to better utilize the stadium, Hershey began booking major music groups that could attract audiences of over 15,000 people. The Star Pavilion was developed to create a stage that would host audiences of 5,000 to 7,000. The pavilion and the stadium share a stage and associated equipment, letting Hershey easily host a broader range of musical performers. (Courtesy of Hershey Entertainment and Resorts Company.)

WILDCATS SOCCER GAME, C. 1999. In 1997, Hershey Entertainment and Resorts launched its own A-League soccer team, the Hershey Wildcats. Their home field was Hershey Stadium until the end of the 2001 season, when the team folded. (Courtesy of Hershey Entertainment & Resorts Company.)

**PADDLEBOATS ON SPRING CREEK,
c. 1995.** Boating is one of the park's
most enduring attractions. Only the type
of boats available to use at the park has
changed over the years. Hersheypark now
rents paddleboats for use on Spring Creek.
(Courtesy of Hersheypark.)

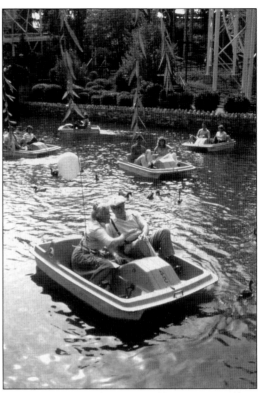

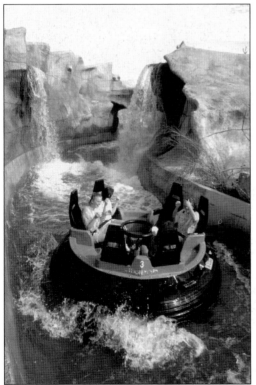

CANYON RIVER RAPIDS, c. 1995. After
a hiatus of 10 years, the park added its first
major new ride with the opening of Canyon
River Rapids in 1987. The addition of this
ride marked the beginning of the Hershey
Entertainment and Resorts' transition to
refocus its energies on its Hershey properties.
Although it would be several years before the
company reestablished a firm financial base,
Hersheypark could look forward to future
improvements. (Courtesy of Hersheypark.)

119

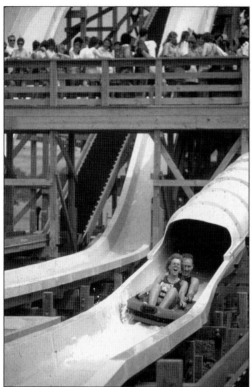

FRONTIER CHUTE OUT, C. 1995. Building on the success of the Canyon River Rapids, the following year Hersheypark added a second water ride, Frontier Chute Out. The water ride features four water slides, two winding tunnels, and two straight open slides. All four slides launch from a 45-foot tower. (Courtesy of Hersheypark.)

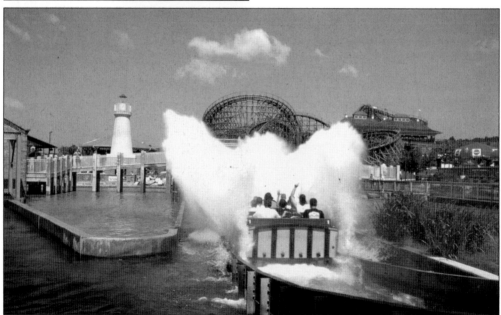

TIDAL FORCE, C. 1996. Opening in 1994, Tidal Force expanded Hersheypark's choices of water rides. The ride was promoted as the world's tallest and wettest splashdown ride. The ride features splash zones for nonriders, areas surrounding the ride where guests are guaranteed to get wet from the ride boats splashing down. The ride also features an observation deck for riders to stand and get wet again as the next boat splashes down. (Courtesy of Hersheypark.)

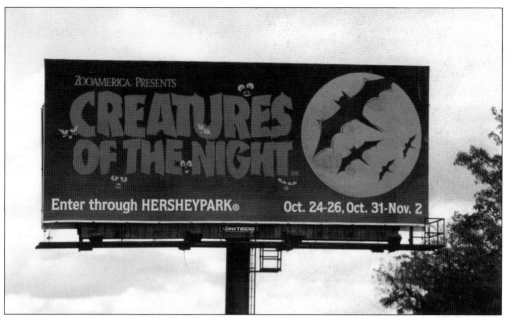

BILLBOARD, C. 1996. In 1981, ZooAmerica launched Creatures of the Night, an educational alternative for Halloween. Visitors were invited to bring a flashlight and experience the zoo by night. Zoo educators offered bat and snake demonstrations, and a storyteller told ghost stories by a campfire. By 1995, the event had expanded to three weekends and included selected rides operating in Hersheypark.

CHRISTMAS CANDYLANE, C. 1995. The original vision for Candylane was to create a European-style Christmas village. It first opened in 1983. Over the years the event has expanded to include rides, special entertainment, shops, and over 800,000 Christmas lights decorating the park.

WAVE SWINGER, C. 2000. Hersheypark added the Wave Swinger to Comet Hollow in 1982, replacing the Bug, which was becoming difficult to maintain. The ride features a swing-type ride combined with a wave-like motion. The ride is particularly dramatic at night, lit by thousands of lights. (Courtesy of Hersheypark.)

FLYING FALCON, 1990. With the construction of this ride, Hersheypark renewed its plans to develop Minetown. The park had had plans to develop the area since 1973, when the Coal Cracker was constructed. Financial constraints had delayed further development of the area until 1990, when the Flying Falcon opened. Over the next few years, the area expanded with a new games arcade, restaurant, and three kiddie rides.

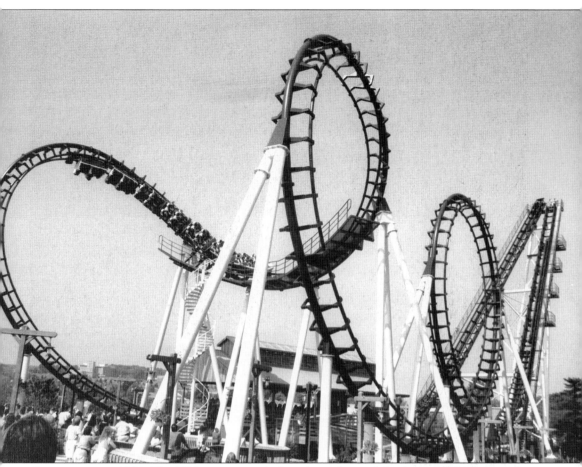

SIDEWINDER, C. 1991. The 1990s was a period of accelerated growth for the park. The Sidewinder was part of the park's expansion of the frontier area. This looping boomerang roller coaster was the park's fourth coaster. Introduced in 1991, the coaster turns its riders upside down six times. Once the ride completes its course, it pauses for a moment and then follows the same path backwards. (Courtesy of Hersheypark.)

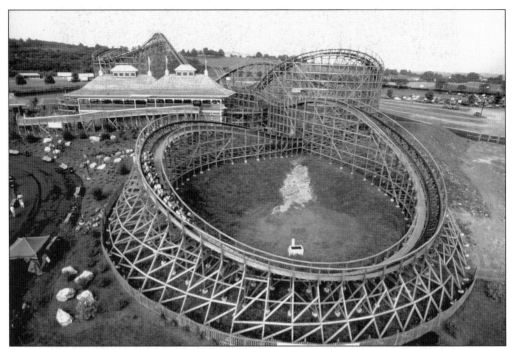

THE WILDCAT, 1996. The Wildcat was Hersheypark's first new roller coaster in 50 years. A cyclone-style roller coaster, the Wildcat follows a circuit of 11 turns, crossing through or over itself 20 times from start to finish. The coaster was designed by Mike Boodle of Great Coasters International. The Wildcat would serve as the anchor for Hersheypark's newest area, Midway America. Midway America was envisioned as an opportunity for the park to feature rides and attractions that had been popular in earlier decades.

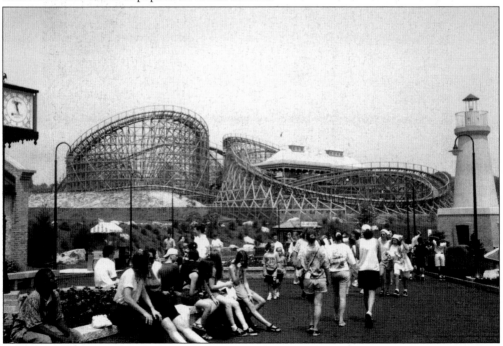

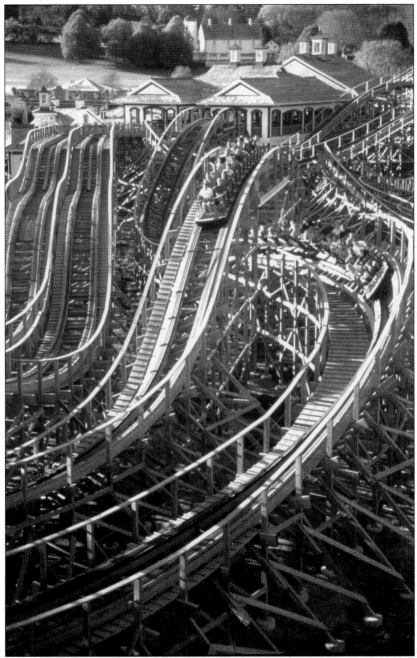

LIGHTNING RACER, C. 2000. Since the construction of the Wildcat, the park has followed a steady course of adding major attractions and rides every other year. These rides have offered visitors a broad range of experiences from high-level thrills to family fun. Roller coasters have included Great Bear, Lightning Racer, Roller Soaker, and Storm Runner. Hersheypark added its eighth roller coaster to its coaster line-up in 2000. The two-track racing coaster was designed and built by Great Coasters International, the same company that designed and built the Wildcat. The two tracks are run simultaneously, allowing riders in the two trains to race against each other. (Courtesy of Hersheypark.)

ROLLER SOAKER FROM THE GROUND, C. 2004. Introduced in 2002, Roller Soaker was billed as an interactive water coaster. The coaster rolls above a water obstacle course created by visitors on the ground who blast water up to the riders as they coast by. Riders are equipped with four gallons of water to soak the spectators below them. (Courtesy of Hersheypark.)

REESE'S EXTREME CUP CHALLENGE, 2006. Seeking to appeal to entire families, in 2006 Hersheypark introduced Reese's Extreme Cup Challenge, a highly unique, highly themed interactive dark ride designed to be fun for guests of all ages. This ride is the park's first dark ride since the days of the park's fun house. The ride incorporates extreme sports motifs, including hockey, BMX biking, in-line skating, and snowboarding, with animatronics figures and special effects to enhance the experience. (Courtesy of Hersheypark.)

MILTON S. HERSHEY STATUE, 2003. To celebrate the community's centennial, Hersheypark commissioned local sculptor David Daniels to create a statue of Milton Hershey based on an archival photograph of him in the park. A special pedestal and fountain were constructed on the site of the Starlight Arcade, and the area was renamed Founders Circle. The statue was dedicated in 2003. (Courtesy of Hersheypark.)

Across America, People are Discovering Something Wonderful. Their Heritage.

Arcadia Publishing is the leading local history publisher in the United States. With more than 3,000 titles in print and hundreds of new titles released every year, Arcadia has extensive specialized experience chronicling the history of communities and celebrating America's hidden stories, bringing to life the people, places, and events from the past. To discover the history of other communities across the nation, please visit:

www.arcadiapublishing.com

Customized search tools allow you to find regional history books about the town where you grew up, the cities where your friends and family live, the town where your parents met, or even that retirement spot you've been dreaming about.